DATE			

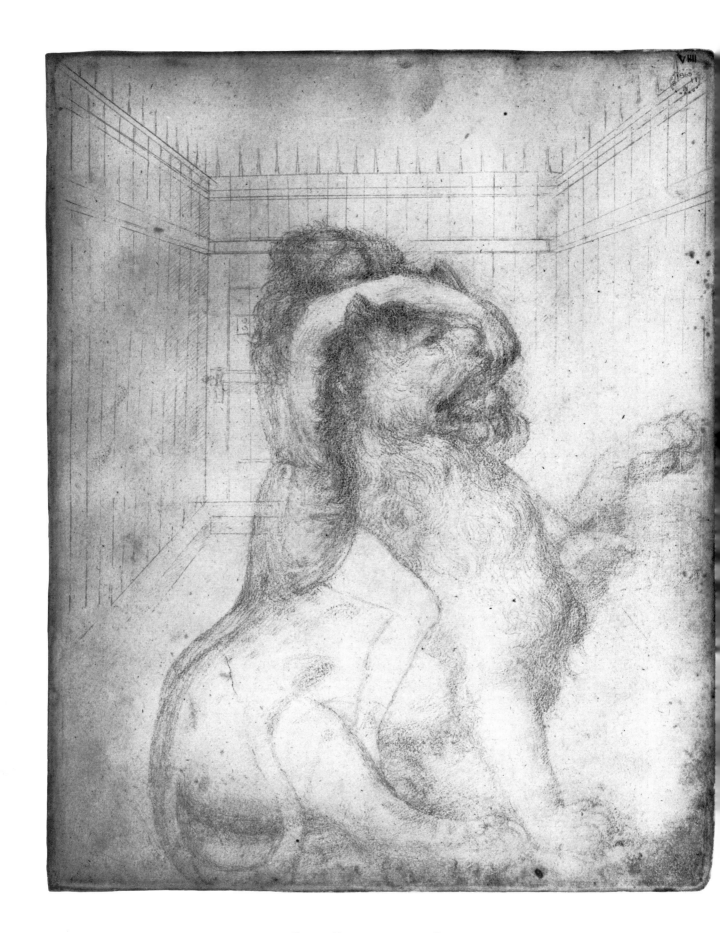

Figure Battling with a Lion.

Jacopo Bellini
SELECTED DRAWINGS

Edited by
Christiane L. Joost-Gaugier

Professor and Head, Department of Art
New Mexico State University

DOVER PUBLICATIONS, INC.
NEW YORK

ACKNOWLEDGMENTS

Editor and publisher are grateful to:

The Trustees and the Keeper of Prints and Drawings, British Museum, London, for supplying photographs of drawings selected from the Jacopo Bellini album in that institution, and for permitting their reproduction.

And to the Library of New Mexico State University for making available a copy of Victor Goloubew's facsimile edition of the Jacopo Bellini drawings, *Les dessins de Jacopo Bellini au Louvre et au British Museum* (2 parts, 1908 and 1912, G. Van Oest & Cie, Brussels), from which most of the drawings in the present volume have been reproduced.

Published in Canada by General Publishing Company, Ltd., 30 Lesmill Road, Don Mills, Toronto, Ontario.

Published in the United Kingdom by Constable and Company, Ltd., 10 Orange Street, London WC2H 7EG.

Jacopo Bellini: Selected Drawings, first published by Dover Publications, Inc., in 1980, is a new selection of drawings reproduced from the sources given in the Acknowledgments. Professor Christiane L. Joost-Gaugier made the selection and wrote the text specially for the present edition.

International Standard Book Number: 0-486-23912-8
Library of Congress Catalog Card Number: 79-53842

Manufactured in the United States of America
Dover Publications, Inc.
180 Varick Street
New York, N.Y. 10014

INTRODUCTION

The reluctance of Venetian artists to adopt Florentine example in the early years of the Renaissance has long been considered a peculiarity in the development of Venetian art. Despite the numerous visits of Florentine artists, many of them in the avant-garde, to the city and region of Venice during the second, third and fourth decades of the Quattrocento,[1] Venetian painters, sculptors and architects remained remarkably aloof from the new ideas and experiments in perspective that were bringing fame to Florence. Even though such a great Florentine master as the sculptor Donatello arrived for an extended stay in nearby Padua as early as 1443, the Venetians did not immediately set to work exploring the harmonizations that might have been achieved in their art through the adoption of Florentine ideas, which aimed at simplifying compositions through the application of a systematized and coherent logical structure. Indeed, the first reaction of many Venetian artists was to borrow details rather than concepts from Donatellian example. In their selection and adaptation, these details appear to have been understood at first as sources of additional decorative elaboration. Thus, the Gothic tendencies prevailing in Venetian art of the time were, ironically, further enriched.

Nevertheless, a strong interest in fusing the traditions of elaborate settings, inherent in Venetian and Paduan painting and illumination, with the new theory of spatial coherence is dramatically exemplified in the work of the Venetian painter Jacopo Bellini. The attitude of this artist, who lived from the beginning of the fifteenth century to about 1471,[2] is extremely progressive. Despite the loss of most of his oeuvre as a painter, we are indeed fortunate to possess two complete books of drawings by this master, one today in the British Museum, London, and the other in the Louvre, Paris.

This corpus, which dates from approximately the middle of the fifteenth century and totals about 229 individual designs, is the largest extant collection of drawings associated with any single master of the early Renaissance in Italy. Further, the two volumes constitute the only extensive collection of surviving examples of drawings kept by any artist of the Renaissance in Venice. These albums are universally recognized to be Jacopo's work and can be traced, through documents, to his time.[3] Because the dozen or so paintings now associated with Jacopo are, on the other hand, of only recent attribution, his volumes of drawings are critical documents in the evaluation of his historical role in the general development of the Renaissance in Venice.

The traditional reference to these volumes as "sketchbooks" appears to be due to nineteenth-century error,[4] for the drawing books of Jacopo Bellini are not sketchbooks in the normal sense. Although surviving sketchbooks from the fourteenth and fifteenth centuries are few in number, certain shared characteristics make them all recognizable as such.[5] As books they are small and contain pages of a humble size, sewn (rather than bound) in such a way as to present a generally vertical format. Their subject matter consists almost exclusively in the repetition of certain established types of patterns or models deriving from the *exempla* drawings of medieval pattern books, in which the objects to be studied provided a sort of compendium from which appropriate details might be selected for inclusion in a painting.[6] The subjects are placed on the sketchbook page either centrally or one above the other, isolated against the white environment of the remainder of the sheet. The volumes of Jacopo Bellini are entirely different. They are considerably larger in size than any surviving sketchbook.[7] The individual folios are also large, and are bound in such a way as to provide for a wide horizontal format as well as for a generous vertical one. Most importantly, the subjects, which are partly imagined and partly studied, are lifelike rather than decorative in concept and are so arranged on the page as to form an independent visual whole. The drawing albums of Jacopo Bellini are unique in that they show, in essence, the transformation of the calligraphic medieval pattern into the notion of the realistic representation, or completed vision, characteristic of the Renaissance.

Another unique feature of Jacopo's drawings is that they do not show signs of the wear and tear—including folding, tearing, pricking and other forms of physical abuse—to which ordinary workshop drawings were subjected. This factor, taken into consideration along with the large format and luxurious aspect of the two volumes, would seem to indicate that the drawings contained in them were intended as display projects whose main purpose—owing to their unusual content, as will be discussed below—was pedagogical. The conspicuously luxurious nature of Jacopo's drawing books was not unnoticed in the past, for an anonymous connoisseur of the early sixteenth century, the so-called Marcantonio Michiel, in speaking of a sketchbook by the Lombard artist Michelino da Besozzo which he had seen in the house of the Vendramin in Venice, described it as a *libretto,* but in speaking of one of Jacopo Bellini's volumes which he had seen in the same collection, called it a *libro grande.*[8]

That these books were highly regarded in their own time is clear, for shortly after their creation they were inherited as treasures, presented and received as gifts, treated as objects of art and, subsequently, owned by sultans, bishops and counts.[9] In her will of November 25, 1471, the wife of Jacopo listed a number of works of art formerly belonging to her late husband that were to be left to her son Gentile;[10]

though she grouped paintings together in a general category, the context in which she specifically mentioned, in advance of the paintings, "all books of drawings" suggests that these books were at least as valued as the paintings. The words of Anna Bellini also suggest that more than two volumes of drawings may have existed. Upon his visit in 1479 to the court of Mahomet II, the Sultan of Turkey, at Istanbul, Gentile Bellini, the elder son of Jacopo and official state painter of Venice, took with him and presented to the Sultan the more elaborate vellum volume today in the Louvre.[11] Why he took the volume with him and precisely how he disposed of it are questions that have not yet been satisfactorily answered. In his own will of February 18, 1507, Gentile bequeathed to his brother Giovanni another of Jacopo's drawing books, presumably the London volume. The unusual measure of respect with which he treated the volume in laying down the conditions on which Giovanni might inherit it clearly indicates that he was bequeathing nothing less than a treasure to his brother.[12] In this sense Gentile, and presumably his brother Giovanni, must be considered to have been among the earliest collectors of drawings.

It is entirely possible that had his two sons Gentile and Giovanni not been honored with fame and fortune, the name of Jacopo Bellini would be unknown today. In fact, when the great Italian critic and first historian of art, Giorgio Vasari, was born in 1511, almost nothing was known about Jacopo, who had died in Venice some 40 years previously. Yet Vasari was to be Jacopo's first biographer. In his biography of Jacopo, which is conjoined with those of his two sons, it is clear that Vasari, on whose work most subsequent historical accounts were based, was able to obtain a great deal more factual information about Gentile and Giovanni, both of whom lived into the sixteenth century.

Modern research, however, has brought to light a number of contemporary and other early notices about Jacopo Bellini that were unavailable to Vasari. These references suggest that this artist, who is now perhaps somewhat deceptively known as a painter of madonnas, was once quite differently appreciated, for they reveal that he was primarily known for his portraits and for his paintings of great narrative sequences.

That Jacopo's fame as a portraitist was secure and well rewarded is known from at least one contemporary account, a sonnet by the Ferrarese poet Ulisse de'Aleotti, who praised the achievement of Jacopo during the artist's visit to the court of Lionello d'Este at Ferrara.[13] The words of Ulisse are significant because they describe the famous contest at the court of Ferrara in which the recently arrived Jacopo was victorious over the established and celebrated artist Pisanello. The object of the competition was a portrait of the new duke, Lionello. While Pisanello's portrait is often thought to be the one now in the Accademia Carrara, Bergamo, Jacopo's is lost. In praising the realism of Jacopo's images, Ulisse described him as "the greatest painter" and referred to him as a "new Phidias." The latter remark has sometimes been construed as suggesting that Jacopo was also

a sculptor. There is, however, no evidence in his surviving work that would support this notion.

In another sonnet by the same author, Jacopo is described as being a great teacher of the "art of nature."[14] The image of Jacopo Bellini as a prominent advocate of the new realism is a recurrent one in the artistic literature of the fifteenth century, for the Pisan poet Giovanni Cillenio also described Jacopo as a most refined teacher who should be highly praised.[15] Given the particularly high regard Jacopo was accorded as a portraitist in his own time, it is ironic that no painted portrait by him is known today.

About 1440, when Jacopo Bellini was approximately 40 years old, an important treatise on perspective was dedicated to him by the Paduan scientist Giovanni Fontana.[16] This honor suggests that Jacopo had already become, as well, an authoritative figure in that field.

From the century following his death we possess little new information about Jacopo. However, knowledge of his activity as a portraitist and teacher of new ways appears to have lingered on. Marcantonio Michiel, the above-mentioned connoisseur of art in Venice and Padua, recorded six works by Jacopo personally seen by him early in the century. Of these six, three were portraits. A fourth was "a large book with pages of heavy paper containing drawings of lead point done by the hand of Jacopo Bellini"—now recognized as the drawing book today in the British Museum.[17] This first mention of a drawing book by Jacopo is also the first indication that he was appreciated as a draftsman, for the album, as we have seen, was in a prestigious sixteenth-century Venetian collection. After this notice the book was to pass into relative obscurity until its rediscovery in the mid-nineteenth century.

In Vasari's pioneering biography of Jacopo,[18] we learn that Jacopo had been a pupil of Gentile da Fabriano and that he expressed his high regard for his teacher by naming his first son after him. Vasari mentioned four works known to be by Jacopo at the time he was writing, two of them portraits and the other two large narrative paintings. Jacopo thus emerges, in the literature of 1565, almost a hundred years after his death, as a master of large-scale fresco cycles.

The reputation of Jacopo Bellini as a painter of narrative series continued into the seventeenth century. The historian Carlo Ridolfi, who devoted a whole chapter of his *Le Maraviglie dell'arte,* written in 1648, to this artist,[19] took great pains to describe a series of some 18 paintings, now lost, representing scenes from the Life of the Virgin and the Passion of Christ executed by Jacopo for the confraternity of San Giovanni Evangelista.

For over one hundred years after this, nothing more is heard about Jacopo, until we learn that a signed painting representing a Madonna and Child was brought to light in 1789.[20] Bearing in mind the fact that the paintings we know today as works by Jacopo are almost exclusively madonnas, it is curious indeed that the first mention of any madonna painting by his hand should have occurred only toward the very end of the eighteenth century.

Interest in Jacopo grew at a fast pace through the nine-

teenth century with the discovery and publication of numerous documents referring to his personal life and artistic activity. Further madonnas were ascribed to Jacopo at this time as was a famous fresco representing the Crucifixion painted for the Cathedral of Verona. The destruction of the Verona *Crucifixion*, which was due to the ambitious remodeling schemes of an abbot of that cathedral, is one of the great losses in the history of Italian art and surely the greatest single loss in terms of Jacopo's work. This piece, completed in 1436, appears to have been regarded by him as the work that marked his first achievement of artistic maturity, for Jacopo's signature included a statement of grateful recognition to Gentile da Fabriano, thereby confirming his debt to his teacher.[21]

Also during the nineteenth century, both drawing albums were rediscovered and descriptions of them published. The German historian Gaye thoroughly described the album which Marcantonio Michiel had seen in Venice in the early sixteenth century. Shortly thereafter, in 1855, the volume was acquired by the British Museum. At about the same time, the album which Gentile Bellini is believed to have taken to Istanbul in the late fifteenth century was found in the attic of a French castle near Bordeaux. Eugène Müntz, in the first published description of the album, rated Jacopo as an important teacher and theorized that his influence on the great Paduan artist Andrea Mantegna, who became his son-in-law in 1453, must have been a significant factor in the development of the art of northern Italy.[22] The volume was purchased by the Louvre in 1884.

As a result of the important additions to our knowledge of Jacopo provided by the nineteenth century, it became apparent that a more prominent place had to be accorded him than had previously been the case in the general literature of art. The main work of twentieth-century writers has centered on this task. Of fundamental importance along these lines was the first—and so far the only—monograph on Jacopo Bellini, published in 1908 by Corrado Ricci, in which the author brought together information, attributions and documents as well as the first comprehensive bibliography concerning this artist.[23]

Almost immediately following the appearance of Ricci's work, which drew attention to the primacy of the drawing books as the basis of our knowledge about Jacopo Bellini, facsimile reproductions were made available to the humanistic world by Victor Goloubew, who published in 1908 and 1912, respectively, two volumes of high-quality reproductions of all the drawings corresponding to the format and arrangement of the two original albums.[24] The numbers assigned by Goloubew to each folio are still generally used for purposes of identification. During the same years Laudedeo Testi allocated a significant chapter to these works in his history of Venetian art. Since that time, discussion of the drawings has dealt almost exclusively with stylistic matters and questions of connoisseurship, to the point that the wider significance of the work of Jacopo Bellini for the Renaissance in Venice has been almost completely obscured.

The drawings of Jacopo are characterized by a taste for elaborate perspective schemes to an extent that suggests he was particularly interested in displaying his virtuosity in this area. Drawings were not, at this time, subject to the same kinds of prearranged conditions as commissioned paintings. Because of its nature, the medium of drawing allows for considerably more spontaneity, freedom and experimentation than does a finished painting. The laborious nature of Jacopo's drawings, considered together with their often obscure iconography, suggests that they were intended as imaginative compositions. Jacopo's buildings are for the most part not particularly close to specific architectural examples; this too points to the deliberate creation of a highly artificial situation rather than to the notation of apparent reality or the duplication of reality itself.

Jacopo's insatiable interest in the achievement of a coherent pictorial space through perspective is evident in the wide variety of methods utilized by him to obtain this illusion. This imaginative variegation was undoubtedly one of the aspects of his work that led some critics, for example the Tietzes, to hold that the drawings represented a miscellaneous accumulation in terms of both style and chronology.[25] However, Marcel Röthlisberger's more recent studies have offered convincing proof that the drawings of both volumes possess a consistency of style that suggests they were produced at approximately the same time rather than at widely different dates.

One method used by Jacopo is an empirical Trecento one in which a general vanishing area is present, but no attempt is made to conform to any specific point or points. Jacopo also appears to have been acquainted with the bifocal method of construction known to have been in use in Padua as early as the fourteenth century. According to this system a point was placed to each side of the composition at either end of the same horizon line, from which diagonal lines were drawn to the lower edge of the sheet, forming an essential network in which strategic objects such as walls and fences might be located. However, although some of his drawings tend to show an orthogonal pull to one side or another, there are no typically bifocal constructions among his drawings.

While a few compositions suggest the use of multiple vanishing points, and some show the use of a vanishing axis located along the vertical bisecting line of a design, the overwhelming majority of his perspective drawings are constructions based on the use of a single vanishing point. Jacopo's insistence on the central vanishing point in those compositions where he chooses to use it—particularly the architectural compositions—is incontrovertible, for in several examples the point can still be seen. Its location on the floor of a centrally planned hemispherically domed church, for example (page 23), shows that Jacopo was exploring the vanishing, or centric, point in an utterly logical way. That the use of a focal point permitted the immediate visual grasp of the space must have been a factor well appreciated by Jacopo. The artist's esteem for the unified viewpoint is also demonstrated by his deliberate, indeed often pedantic, attempt to force the lines of an adjoining scene, for example

the left-hand side of a double-page composition, into the same perspective scheme as the principal scene. It is evident as well in a number of landscape drawings in which tree trunks, plowed fields and hedges are aligned so as to be consistent with the vanishing point of the design (pages 29 and 42).[26]

Jacopo appears to have been acquainted also with Albertian notions of spatial construction. Although it might be argued that because he does not always use a single centrally located vanishing point he is not truly Albertian, it can on the other hand be shown that he demonstrated theoretical conclusions relating to the application of perspective rules that are precisely Albertian. As we have seen, the convergence of lines toward a single centrally located point, when it is stated by Jacopo, is clearly stated. It is also clear that, in accordance with Albertian precept, Jacopo divided his base line into sections to establish squares. Further, he appears to have utilized those squares to form a consistent system for determining the measurement of the human inhabitants of the spaces thus created. The human inhabitants are so variegated and so strategically placed within the compositions as to fulfill Albertian requirements for the construction of an *istoria.*

The precepts outlined by Alberti, who was the most important Florentine theoretician of the arts in the Quattrocento, for obtaining space were accompanied by recommendations for populating that space with figures who in the variegation of the physical type, behavior and role chosen for them by the artist suggested, as it were, a carefully constructed sociological reality coinciding with and complementing the coherent organization of the space. These instructions were based on the notion that the space is laid out first and later populated. That Jacopo followed this general rule can be noted in a number of his designs (e.g., page 19) where the construction lines are still visible beneath the figures. Further, as can still be seen in a few drawings (e.g., page 13), Jacopo first drew nude bodies and subsequently clothed them; this too reveals that he knew Albertian precept and applied it.[27] It must, however, be stated that although Jacopo's general aim appears to have been Albertian in that he attempted to construct legible, divisible and continuous spaces and to justify them through the inclusion of human incident, he appears to have regarded absolute geometrical accuracy (upon which Alberti insisted) as perhaps too mechanical for his elaborate compositional tastes, which are firmly rooted in northeastern Italian tradition. In this sense it might be argued that Jacopo's appreciation of Albertian ideas was realized in their application by rule of thumb.

Like yet another Florentine, Brunelleschi, Jacopo Bellini saw the pictorial representation of architecture as the primary means of illustrating by application the extension of solid objects into depth. Jacopo's use of architecture as pure subject matter has no precedent in the art of his forerunners and contemporaries in Venice (page 23). Indeed those drawings of his in which architecture forms the focus of interest are conceived at a level of sophistication and in a context that, distinct from the devotional images popular in Venetian art of the mid-Quattrocento, raises and explores theoretical issues related to those that preoccupied Florentine artists of the same period. This, along with his emphasis on the illusion of space, confirms Jacopo's remarkable interest in and appreciation for Florentine ideas.[28]

The significance of Jacopo Bellini's drawings is very broad in terms of its consequences for the future of Venetian painting. Of primary importance among the innovations he proposed is the introduction of perspective as subject matter. Despite its roots in Paduan style in the works of such artists as Altichiero and Avanzo, this constituted a radical departure from Venetian tradition, in which the devotional image had always predominated. In Jacopo's eagerness to use every possible device to achieve coherency of space and continuity of depth, he frequently relegated the religious subject to the middle ground and background of his compositions, where it came to acquire far less importance. Scenes depicting traditional religious themes are often lost in complex displays of scenery and descriptive compilations of everyday events. In his efforts to concentrate on the articulation of a construction and the accompanying lifelike and dramatic details that might justify the space, Jacopo proposed, for the first time in Italian art, the secularization of religious iconography.[29]

This is especially apparent in Jacopo's use of landscape. His interest in the application of the idea of artificial perspective to landscape, although not possible according to Albertian rule, which is based on the use of the straight lines inherent in buildings and walls, was a logical extension of his explorations in this domain. The drawings involving landscape are characterized by the provision of a complete visual setting for the episode; the implied reproduction of coherent natural settings may suggest at times (e.g., page 37) an almost portrait-like resemblance to specific places. This new attitude to landscape, in which it emerges as a primary subject, is evidence of a decisive theoretical break with the past, when the significance of landscape was definitely secondary and it was meant to function as an annotation or complement to the devotional image that dominated the design.

In being the first Venetian artist to propose the rationalization of space, Jacopo Bellini suggested, as part of his visionary attitude, that traditional form and subject matter ought to be subordinated to a new vernacular in which lofty themes are obscured by a concentration on the pictorial, if not the systematic, layout of a scene so constructed as to suggest that it represents a slice of life. To this compromise are correlated the emerging vocabulary of narrative, genre and landscape. The result is the most secular type of religious iconography that exists in the fifteenth century, one that looks forward to the work of Giorgione, Titian and other masters of the next century. Moreover, the completed pictorial compositions of Jacopo Bellini form the basis of that tradition which was to become known as Venetian: *fare, del disegno, pittura* ("make, by drawing, paintings").

NOTES

1. Alberti himself had spent the greater part of his youth in the area, which he appears to have revisited in 1438. Masolino is known to have spent some time in Venice in the 1420s in connection with his trip to Hungary. The major Florentine architect Michelozzo not only spent several years in Venice in the mid-1430s but was responsible for the construction of a library at San Giorgio Maggiore. Uccello spent many years in the area, first as a mosaicist in Venice in the later half of the 1420s and again in the mid-1440s as the painter of an important, but now lost, fresco series in Padua. Fra Filippo Lippi's sojourn to this area in 1437 is also well known, not to mention that of Andrea del Castagno, who was employed in the renovative decorations of the church of San Zaccaria at Venice in the early 1440s.

2. Although Vasari tells us that Jacopo was born in 1400 (Giorgio Vasari, *Le Vite de'più eccellenti pittori, scultori ed architettori*, ed. G. Milanesi, Florence, 1878, III, p. 149), there are many reasons for believing Jacopo may have been born in the late fourteenth century, among them the fact that we now know that Gentile da Fabriano, Jacopo's teacher, was working in Venice in 1408. Since most scholars assume that Jacopo Bellini first became employed by Gentile in Venice and later followed him to Florence, where his presence is documented for 1423, it would appear that Jacopo was more than eight years old in 1408. The death of Jacopo Bellini occurred sometime between January 7, 1470, when he is mentioned in a document as still living, and November 1471, when from the will of his wife, Anna Rinversi Bellini, it is evident she has become a widow. Both documents are reprinted in Corrado Ricci, *Iacopo Bellini e i suoi libri di disegni*, Florence, 1908, I, pp. 58–59.

3. The volume in the British Museum contains 99 folios, or 198 pages, and a total of 134 drawings. Some of the drawings are contained on a single page, while many extend over two pages, forming "double" drawings. Since the double drawings form uninterrupted homogeneous units, it is now generally recognized that the bound volume must have existed before the drawings. The present binding, Moorish in style, is usually dated about 1500, though the first page bears the inscription "De mano de ms iacobo bellino veneto 1430 in venetia." It is possible that the inscription, generally thought not to be in Jacopo's hand, was added when the book was rebound with its present cover, despite the fact that the handwriting appears to belong to the fifteenth century in that it is small and tightly constructed. The drawings are in lead point on a heavy paper known as *bombasina*. Some have been wholly or partially reworked with pen. The volume in the Louvre consists of 92 folios, or 184 pages, with a total of 95 drawings, 14 of which are double. Except for a single paper page, probably inserted later when the book was rebound, all the folios are of fine white vellum. Only 19 of the pages contain silverpoint drawings, which appear to have replaced prior drawings on each of these pages; most of the remaining drawings are executed in pen and ink directly on the vellum. Clearly, this book also existed in more or less its present form prior to the execution of the drawings. It too appears to have been rebound about 1500. Most probably it was at this time that the index was inserted. A few of the drawings in the book are not listed in the index, while 13 of the items listed are missing. For the main literature on the two volumes and discussion of their provenance, see esp. Ricci, *op. cit.*; Hans Tietze and E. Tietze-Conrat, *The Drawings of the Venetian Painters in the 15th and 16th Centuries*, New York, 1944, pp. 101ff.; Marcel Röthlisberger, "Nuovi aspetti dei disegni di Jacopo Bellini," *Critica d'Arte*, XIII–XIV, 1956, 84–88; *id.*, "Notes on the Drawing Books of Jacopo Bellini," *Burlington Magazine*, XCVIII, 1956, pp. 358ff.; and *id.*, "Studi su Jacopo Bellini," *Saggi e memorie di storia dell'arte*, II (1958–59), pp. 41ff.

4. The volume now in the British Museum was first referred to as a sketchbook by Cavalcaselle: "One thing alone is certain," he declared, "Jacopo Bellini had a sketchbook" See A. Crowe and G. B. Cavalcaselle, *A History of Painting in North Italy*, London, 1871, I, p. 103. The designation has, in general, stuck ever since.

5. Regarding sketchbooks of this period see esp. A. van Schendel, *Le dessin en Lombardie jusqu'à la fin du XVᵉ siècle*, Brussels, 1938, pp. 60ff.; Charles de Tolnay, *History and Technique of Old Master Drawings*, New York, 1943, pp. 30ff.; and R. W. Scheller, *A Survey of Medieval Model Books*, Haarlem, 1963. For further citations see C. L. Joost-Gaugier, "The 'Sketchbooks' of Jacopo Bellini Reconsidered," *Paragone*, 298, 1974, pp. 35–37.

6. Regarding *exempla* drawings and pattern books see de Tolnay, *op. cit.*, and Scheller, *op. cit.*

7. The leaves of the British Museum album measure approximately 41.5 x 33.6 cm and those of the Louvre book approximately 42.7 x 29.0 cm. Measurements of folios in surviving sketchbooks range from 9.5 x 9.0 cm. to about 23.5 x 17.7 cm. See Joost-Gaugier, *op. cit.*, p. 37.

8. Marcantonio Michiel, *Notizie d'opere di disegno*, Bologna, 1887, pp. 221 and 108.

9. Regarding the subsequent history of both volumes, see Tietze and Tietze-Conrat, *op. cit.*, pp. 102 and 107.

10. The will is reprinted in Ricci, *op. cit.*, I, p. 59.

11. The literature on this subject is summarized in Tietze, *op. cit.*, p. 107.

12. The album of drawings by their father was bequeathed to Giovanni by Gentile on condition that Giovanni complete the *Preaching of St. Mark*, a painting still incomplete at the time of Gentile's death; according to the terms of the will, if the work was not completed the album would be directed to the care of Gentile's widow. With regard to the will see René de Mas-Latrie, "Testament de Gentile Bellini," *Gazette des Beaux-Arts*, XXI, 1867, pp. 286–88.

13. The sonnet was discovered and first published by Adolfo Venturi in 1885. It was reprinted in *Le Vite di Gentile da Fabriano e il Pisanello*, Florence, 1896, pp. 46–47.

14. See Ricci, *op. cit.*, I, p. 52.

15. See Ricci, *op. cit.*, I, p. 58.

16. Giovanni Fontana's relation to Paduan scientific tradition is discussed in R. Klein, "Pomponius Gauricus on Perspective," *Art Bulletin*, XLIII, September 1961, pp. 211ff. Regarding his (now lost) treatise on perspective, see summary in Joost-Gaugier, "Considerations Regarding Jacopo Bellini's Place in the Venetian Renaissance," *Arte Veneta*, XXVIII, 1975.

17. See note 8 above.

18. Vasari, *op. cit.*, pp. 149ff.

19. Carlo Ridolfi, *Le Maraviglie dell'arte*, ed. Detlev von Hadeln, Berlin, 1924, I, pp. 52–58.

20. The painting was published by Luigi Lanzi, in *Storia pittorica della Italia*, 4th ed., Florence, 1822, II, p. 18. Regarding this painting, now in the Accademia at Venice, see S. Moschini-Marconi, *Gallerie dell'Accademia di Venezia: opere d'arte dei secoli XIV e XV*, Rome, 1955, no. 23.

21. The relevant documents are reprinted in Ricci, *op. cit.*, pp. 59–61, together with a letter of July 1, 1759 describing the unfortunate destruction of this picture and a series of poems that attest to the fact that it was a famous and much admired painting.

22. E. Müntz, "Jacopo Bellini et la Renaissance dans l'Italie Septentrionale," *Gazette des Beaux-Arts*, 2nd per., 1884, I, pp. 346–55, and II, pp. 434–46.

23. Ricci, *op. cit.*

24. Victor Goloubew, *Les dessins de Jacopo Bellini*, Brussels, 1908 and 1912.

25. Cf. Tietze, *op. cit.* and Röthlisberger, *opp. cit.*

26. See Joost-Gaugier, "Jacopo Bellini's Interest in Perspective and its Iconographical Significance," *Zeitschrift für Kunstgeschichte*, XXXVIII, 1975, pp. 16 and 23ff.

27. See *id.*, "'Subject or Nonsubject' in a Drawing by Jacopo Bellini," *Commentari*, XXIV, 1973, pp. 148ff., as well as following note.

28. This notion is discussed in Joost-Gaugier, "A Florentine Element in the Art of Jacopo Bellini" and "The Tuscanization of Jacopo Bellini (Parts I and II)," *Acta Historiae Artium*, XXI, pp. 359ff., XXIII, pp. 95 ff., and XXIV, respectively.

29. See the work cited in note 26 above.

LIST OF DRAWINGS

All the folios of the British Museum album are of *bombasina* paper and measure approximately 41.5 x 33.6 cm. Those of the Louvre album are of vellum and measure approximately 42.7 x 29.0 cm. Since none of the drawings in either album relate in a specific way to any known painting or work of architecture or sculpture, they cannot be dated with more precision than can the volumes themselves. The folio numbers (a = recto, b = verso) given here are those recorded by Goloubew in his publication *Les Dessins de Jacopo Bellini.* The titles are supplied by the present editor.

Frontispiece. FIGURE BATTLING WITH A LION. Lead point, retouched. British Museum, fol. 9a. Although Goloubew believed this figure to be a classical subject such as a Hercules, and Testi suggested it was a Samson, the theme of a human figure battling with a lion is known in examples of contemporary *novella* literature. The carefully planned orthogonals and transversals of the surrounding fence not only recall Florentine perspective methodology, such as can be seen in the receding planks of the ark in Uccello's *Flood* in Sta. Maria Novella, but also show that the space was laid out before the figures were sketched in. (The facing page in the album shows caged lions.)

1. LANDSCAPE WITH WELL. Lead point, retouched with pen. British Museum, fol. 28b. The open distance of this landscape suggests the artist's interest in demonstrating spatial recession. The extreme faded condition of the forms in the background suggests a distant landscape that was only lightly sketched, implying that many intervening planes are present between foreground and ultimate distance. In the space thus created a well and a partially constructed block have been placed. Both of these introduced elements are concerned with the solution of perspective problems. In the album, the mountain range continues across the right-hand page, which features a representation of St. Christopher carrying the Christ Child.

2. SOLDIER BATTLING A DRAGON. Lead point, slightly retouched. British Museum, fol. 10a. If this figure represents St. George, as Goloubew believed, it is iconographically unique because the scene is shown taking place in a Venetian courtyard rather than in a country landscape and because the figure is shown wearing Roman rather than medieval or contemporary armor. The position of the figure as well as his costume suggests that Jacopo Bellini studied Roman sarcophagi. The drawing may be considered to reflect an early interest in antiquity in Venetian art. The architecture extends onto the left-hand page, not reproduced here, which shows a young woman standing in a loggia.

3. ST. GEORGE AND THE DRAGON. Lead point, partly retouched. British Museum, fol. 12a. Although the horse has a long history in Venetian art, such a lively representation of a rearing horse with an emotionally engaged rider is unusual in this early period. The left-hand page shows the princess dressed as a bride and, as she is rescued by the act of the saint, fleeing into a hilly landscape which shows a partial view of a distant palace.

4 & 5. EQUESTRIAN MONUMENT (lead point, partly retouched with pen) and THREE SAINTS IN NICHES (lead point, retouched). British Museum, fols. 27b and 28a. Whether or not the left-hand subject is connected with Jacopo Bellini's visit to Ferrara in 1441, as suggested by the presence of heraldic eagles which may refer to the Este family, it certainly reflects the new interests of the Renaissance in reviving antique equestrian subject matter. Equestrian heroes were most frequently shown from the side in paintings of this period, so that this drawing is unusual for its frontal view, and suggests a desire to achieve dramatic spatial recession. The figures of saints on the right-hand page, representing St. Peter, St. John the Baptist and probably an evangelist, are remarkable for the interest they reveal in articulating a *contrapposto* position in an individualized spatial setting. Aspects of these figures recall examples of early Florentine sculpture by such artists as Donatello and Ghiberti.

6 & 7. BUCOLIC FIGURES. Lead point, retouched. British Museum, fols. 33b and 34a. These figures probably represent specific subjects whose sources may be found in contemporary dramatic literature or poetry. The decisively bucolic nature of the scenes is evidence of the new interest of Jacopo Bellini in everyday subject matter and genre.

8 & 9. RUSTIC SCENES. Lead point, retouched. British Museum, fols. 36b and 37a. These subjects, which form two halves of a double drawing, show further evidence of Jacopo Bellini's interest in genre. On the right a peasant is shown on an aged horse before the simple cottage of a *contadino,* while on the left a farm scene is laid out utilizing a variety of perspective devices such as a brick tower, a ladder and a scaffolding.

10 & 11. LANDSCAPE and DAVID WITH THE HEAD OF GOLIATH. Lead point, retouched. British Museum, fols. 44b and 45a. In the drawing to the right David is shown as a mature figure on a rearing horse holding the head of the slain giant aloft before a crowd gathered outside the city, while in its pendant to the left an extensive landscape is laid out. The setting incorporates a river which, together with a variety of staggered subjects including a leafless tree in the middle ground and two stags in the foreground, helps to establish the distance. The presence of such figures as the two men hanging from a gallows and the horse and rider crossing a low bridge has nothing to do with the main theme. Rather, the significance of these contents seems to lie in that they provide a descriptive language suggesting an everyday, or secularizing, context which in being attached to the theme helps to make it appear more real. The construction lines which are still evident in the main composition clearly suggest that their function was to govern the placement and size of the distant figures and that, therefore, the space was conceived before it was populated. That these two drawings were intended to be continuous is revealed by the fact that the mountain located in the center is shared by both.

12. DAVID AND GOLIATH. Lead point, partly retouched with pen. British Museum, fol. 46a. Jacopo Bellini's independence from iconographic consistency is revealed in this drawing. Whereas in the preceding example David was depicted as a mature hero, here he is seen as a small child. A winding road and receding mountains in the distance help to suggest an extensive environment in which are placed figures whose smaller size and diminished intensity suggest spatial recession. The left-hand album page continues the landscape and adds elements of architecture to which are conjoined several more figures.

13. JUDGMENT OF SOLOMON. Lead point, retouched. British Museum, fol. 47a. This scene is shown taking place in a large palatial courtyard whose shape is established and controlled by orthogonals that derive from a large barrel vault and recede into the center distance. That the space was laid out first and the figures subsequently placed in it can be seen from the construction lines of the composition, still visible through the figures. It would appear that Jacopo first sketched the figures nude and later clothed them in finishing his composition. The left-hand album page shows another courtyard area containing figures and horses.

14 & 15. FIGURES IN A COURTYARD and PUNISHMENT OF A CRIMINAL. Lead point, retouched. British Museum, fols. 50b and 51a. In the right-hand part of this double drawing the partially clothed body of a man is shown being dragged by a horse in the courtyard of a palace complex, while to the left figures armed with lances direct and control the activity. The nude bodies of these figures are still evident beneath the drawing of their clothes. The relation between the architectural design and the perspective layout indicates that the two pages of this drawing were conceived

together; this is confirmed by the continuation of the horse's hoof from one page to the other. These factors constitute evidence that the book existed before the artist drew on the folios.

16 & 17. TOURNAMENT SCENE. Lead point, retouched. British Museum, fols. 54b and 55a. In this double drawing representing a single event, a generous space is provided by the use of perspective. In the pre-created space are represented a variety of figures who give it dramatic interest. The architecture, especially in the lower loggia, suggests that certain Tuscan characteristics were popularized in the two-dimensional art of Jacopo Bellini before they became common in Venetian building practice.

18. HARVEST SCENE. Lead point, retouched. British Museum, fol. 59b. It has been suggested, probably wrongly, that this scene, traditionally thought to be a harvest scene, may represent a bathhouse or construction scene. In any case, the fundamental subject of the drawing appears to be its perspective layout. The design is clearly conceived with a single vanishing point to which both orthogonals and transversals are coordinated. The figures are evidently less important than the structure, since the construction lines are still visible through them. Their anonymity suggests that Jacopo Bellini viewed the human figure as a compositional rather than an iconographical tool, that is, in terms of its ability to lend strategic value to verify the space. If the drawing in fact represents a harvest scene, the nudity of the figures, who are not yet clothed and therefore inappropriate in a harvest scene, suggests Albertian practice. (The facing page in the album, an Adoration of the Magi, is totally unrelated.)

19. STREET SCENE. Lead point. British Museum, fol. 65b. This drawing constitutes the left half of a double drawing in which the right side is devoted to the representation of the Raising of Lazarus. In this part of the composition a street scene is laid out in which buildings provide the primary subject matter. In the space created by the architecture figures engaged in everyday activity are strategically located. The lines of the compositional layout can still be seen through the figures.

20 & 21. ARCHITECTURAL SCENE and MARRIAGE AT CANA. Lead point, retouched. British Museum, fols. 72b and 73a. Although these scenes are represented on opposite pages, there appears to be no evidence that they were conceived as a double drawing except for their relation as an exercise in perspective. The iconographical ambiguity of this double composition is accentuated by the use of the figures in the marriage scene as spatial notations rather than as primary subject matter. The narrative technique with which the main human groupings are introduced—by figures located outside the architecture—suggests a break in the barrier between the picture space and the space of the spectator recalling developments in contemporary theater of the time.

22. PALACE OF HEROD. Lead point. British Museum, fol. 75a. The vast palatial setting of this composition is evidence of the unusual freedom of treatment accorded by Jacopo Bellini to traditional religious subject matter. The Feast of Herod, which takes place to the far right of an upper balcony, and the various phases of the accompanying events, are hardly recognizable in this extraordinary display of everyday appearance and activity. A new technique used here and in other drawings by Jacopo is that of allowing the spectator to experience the simultaneity and sequentiality of events. This device, developed in post-Boccaccian literature, contributes, together with the artist's fascination with architectural detail, to the achievement of a concentration on direct physical experience. The left-hand page in the album contains an architectural study curiously unpopulated, or not yet populated, with figures.

23. ARCHITECTURE. Lead point, retouched. British Museum, fol. 75b. This drawing is an example of Jacopo's use of architecture as pure subject matter. In its centralized architecture, the original vanishing point can still be seen, located on the floor of the building and directly under its dome. That the position and size of the dome were troublesome to the artist is suggested by the evidence of several prior efforts which were rubbed out. The open portal leading the eye directly into and through the building is a centralizing perspective device later to be popularized in the art of Perugino and Raphael. (The right-hand page in the album contains a completely independent Annunciation scene.)

24. LANDSCAPE. Lead point, retouched. British Museum, fol. 76b. This drawing shows that Jacopo Bellini was a student of the Tuscan notion of aerial perspective. By sensing the space-creating potential of the majestic shape of the mountain, he is able to suggest a definition of space without a network of lines, thereby implying, through the diminution of shape and the increasing imperceptibility of form, the existence of an atmospheric haze in the interval separating foreground and background. This page is a continuation from the right-hand album page, which is dominated by a Crucifixion scene.

25. CHRIST NAILED TO THE CROSS. Pen. Louvre, fol. 7a. Though it occurs in the center of the composition, the actual nailing of Christ to the cross is almost lost in the richly elaborated pictorial display, in which a variety of figures, actions and events serve to enrich the theme and to lend it a sense of verisimilitude. In acknowledging the potential of lances, spears, ladders and other such devices for suggesting a framework that depends on orthogonals and transversals, Jacopo may have been inspired by the work of Uccello, who used these and other such space-creating devices to suggest pictorial depth. (No scene faces this one in the album.)

26. THE DEAD CHRIST. Pen and brush. Louvre, fol. 7b. In this composition the architecture of the tabernacle appears to have been more important to the author of the drawing than the devotional image it contains. In the rich-

ness and variety of its classical vocabulary the design of the tabernacle suggests Tuscan prototypes. The imaginary nature of the architecture of the frame is clearly stated in the fact that the pilasters to either side contain different and unrelated decoration. The half-length devotional image of this type was to be popularized in the art of Jacopo's son Giovanni.

27. FLAGELLATION. Pen. Louvre, fol. 8a. The ostensible theme occurs, from the point of view of its location, as a minute notation in the spatial complexity of a vast architectural array, while from the point of view of its iconography, it is diluted by the presence of distracting subjects that are given more prominence. These include a mounted Turk who carries a lighted torch, a small boy who offers a lantern to an elderly Jew, a wolf chained to the floor, and two observant children who, alone, occupy the middle foreground traditionally reserved for the dominating devotional image. The latter figures, who by looking in on the scene function as observers from within, thereby inviting the viewer's participation, suggest an attention to Albertian precept. The variety of age groups and types and the diversity of the involvement of the figures in the composition further bring to mind Alberti's concept of *istoria*. The placement of the figures is coordinated with the perspective articulation of the space, which is in turn controlled by the architectural layout. The idea of an open central area enclosed by walls on either side and a barrel vault above (the so-called triumphal-arch setting, in which a perspective view is initiated and at the same time controlled) suggests an origin in contemporary dramatic practice. The connection between the theme of the Flagellation and the story of Hercules and the Rape of Deianeira, depicted in the two roundels in this and other Flagellations by Jacopo, is obscure.

28. ASCETIC PREACHING. Pen. Louvre, fol. 9a. While the type of the preacher recalls that of St. John the Baptist, there is no conclusive imagery connected with this figure. Rather the scene maintains a distinctly secular flavor, not only in the variegated activities of the foreground but because of the unusual background, in which a harbor scene is painstakingly represented. The projection of the toes of the preaching figure over the edge of the pedestal is reminiscent of the free-standing sculpture of Ghiberti and Donatello. The scene is viewed through an opening that appears to be a deliberate contrivance to lure the spectator into the depth of the perspective, a concern continued by the tiny figures in the background who are viewed from the back as they too become spectators of the ultimate distance. It is possible that the internal framing of the composition is linked to Alberti's concept of seeing through a window. The style of decoration of the framing arch, however, with its pictorial reliefs derived from Gothic architecture, occurs in a number of Flemish paintings of the fifteenth century. (The facing page in the album is blank.)

29. PRESENTATION IN THE TEMPLE. Pen. Louvre, fol. 10a. In this scene of the Presentation of the Virgin, Jacopo

Bellini appears to have appreciated the Albertian notion that a tiled floor might be used as the key element in calculating the size of his figures. He goes beyond Albertian precept, however, in attempting to suggest that the landscape might be organized so as to suggest the orthogonals and transversals of a unified perspective view. Besides showing human figures of varying ages and occupations within the design, the artist enriches the scene through the inclusion of horses, a small dog and a deer. (The facing page is blank.)

30. FUNERAL OF THE VIRGIN. Pen. Louvre, fol. 11a. In the faces of the apostles carrying the bier on which the dead body of the Virgin is extended, as well as in the faces of the figures in the crowd to the right, are contained some of the most remarkable studies of human expression to be seen in the work of this artist. A variety of vignettes, such as a baby feeding a small dog and a child frightened by a tortoise in the foreground, as well as a beggar approaching a horse and rider in the left background and a mounted knight entering the scene from the far right, have little to do with the religious theme and serve, rather, because of their everyday descriptive nature, to complete the visual setting. (The facing page is blank.)

31. MEMENTO MORI. Pen. Louvre, fol. 12a. While the representation of a dead body laid out on top of a sarcophagus is not in itself unusual at this time, the allegorical content of this particular drawing is unique. Although a clue to the identity of the dominant figure may lie in the fact that his head rests on a book, the artist appears to have been less concerned with the identity of the corpse than with organizing the figures who attend a lecture, perhaps religious in nature since all the figures are dressed as monks, in the scene inserted within the scene. (The facing page is blank.)

32. ST. GEORGE AND THE DRAGON. Pen. Louvre, fol. 14a. Although the authorship of this drawing by Jacopo Bellini is unquestionable, it is the only one on paper in the Louvre volume. It appears to have been mistakenly inserted in a later rebinding. A series of tree trunks and dead trees is sketched in a recessive arrangement leading the eye of the spectator into the distant background. (The facing page is blank.)

33. FLAGELLATION. Pen. Louvre, fol. 15a. Though this elaborate composition is centralized, the main theme is not instantly perceivable because it occurs off center from the major focus of the design. Albertian procedure is suggested not only in the layout of the pavement and the variegation in the figures contained on it but, as well, in the divisions of the base line which serve to regulate the pavement divisions. The fact that several of the figures carry lanterns or torches suggests that this may have been intended as a night scene. The two buttressing figures located in the lower right and left corners of the design appear by their gestures to be inviting the spectator's participation. (The facing page is blank.)

34 & 35. FEAST OF HEROD. Pen. Louvre, fols. 15b and 16a. In this double drawing the Feast of Herod is represented as taking place in an upper loggia to the far right of the composition. The fact that the main event takes place entirely away from and almost hidden from the main perspective focus of the drawing may be considered an aspect of Jacopo's interest in secularization. That interest is manifest in the iconographic anomalies he proposes. A horse and rider, a leaping greyhound, a chained bear, a horse drinking from a fountain, a performing monkey, a crow perched on a tie rod, and various conversing figures are preeminent in the design and serve to describe the life that goes on in the courtyard below, while at the same time and almost imperceptibly wedded to these incidental events, Salome begins to ascend the staircase, holding before her the head of St. John the Baptist, whose decapitated body is represented in the distant lower background.

36. CHRIST CARRYING THE CROSS. Pen. Louvre, fol. 19a. This event from the Passion of Christ is almost lost in the extensive narrative panorama laid out by Jacopo Bellini, in which construction workers are shown repairing a wall, a sculptor carving a statue, a fallen rider being assisted and a group of figures being questioned by a soldier as they cross a footbridge. The bricks and stones of the partially constructed wall, in addition to the scaffolding laid across it, serve to suggest depth through rectilinear means, as well as to provide insight into architectural practice of his time. (The facing page is blank.)

37. ST. CHRISTOPHER. Pen. Louvre, fol. 21a. The complete visual setting provided in this drawing would indicate that the landscape and its layout, which suggest an attempt to force nature to conform to the rules of perspective, are more important than the iconographical significance of the figure group. Because this landscape bears a close resemblance to the tilled flat fields of the northern Veneto, from which the distant foothills of the Alps can be seen, it is possible that this may be the earliest surviving drawing in which an actual place is portrayed.

38. PORTRAIT STUDY. Silverpoint on blue ground. Louvre, fol. 22a. This drawing represents the only known surviving portrait by the hand of Jacopo Bellini. The identity of the sitter is unknown. Traces of another drawing beneath the present one suggest that Jacopo used the silverpoint technique, which requires a prepared opaque ground, to obscure a preexisting drawing.

39. JUDGMENT OF SOLOMON. Pen. Louvre, fol. 25a. In this lower part of a double drawing a setting is clearly visualized as it might occur in real life; it is completely described and the major events occur in context rather than dominating the scene. Included is a full supporting cast of figures who act simultaneously as well as sequentially. Jacopo's innovative assimilation of Albertian perspective ideology is apparent in this drawing despite the rich overlay of Venetian architectural ornament on the buildings. The left-hand page completes the roofs and towers.

40. PRESENTATION IN THE TEMPLE. Pen. Louvre, fol. 28a. This depiction of the Presentation of the Virgin shows that, like Alberti, Jacopo Bellini was convinced that a composition had to be structurally coordinated in order to suggest a coherent view. In this drawing he achieved a greater unity between figures and architecture in building the pictorial space than had so far been proposed in Venetian art. The construction lines of the architecture are, in several instances, clearly visible through the figures. (The facing album page is blank.)

41. ANNUNCIATION. Pen. Louvre, fol. 29a. This lower half of a double drawing (the facing page merely completes the architecture) shows that Jacopo Bellini was striking out from the mainstream of Venetian art in an entirely new direction. The receding lines of the architecture, with the resulting articulated foreground space, call to mind Florentine compositions of this subject of the second, third and fourth decades of the Quattrocento, beginning with a lost *Annunciation* by Masaccio, which depend on the expression of architectural depth. Additional orthogonals and transversals are suggested in a fragmentary way in the representation of incidental objects such as the column lying on its side and the brickwork of the wall in the foreground and the bridge to the far left. In the present composition the figures appear to be comparatively inconsequential, suggesting that for Jacopo Bellini the religious content had relatively little importance.

42. DEPOSITION AND LAMENTATION. Pen. Louvre, fol. 34a. Whereas in the work of his contemporaries the figures enacting themes such as this are still by and large confined to the foreground, Jacopo attempts to stage his figures throughout the visual area or, as it were, to lock them into a contemplated space. In this case the placement of the figures is determined by controlling the landscape through perspective, that is, by applying to landscape rules that were formulated to define architectural boundaries. (The facing album page is blank.)

43. CHRIST BEFORE PILATE. Pen. Louvre, fol. 35a. Jacopo Bellini reveals in a drawing such as this one that his art has a decorative as well as a theoretical aspect, for side by side with ideas of perspective composition he demonstrates that he has accumulated a repertoire of motifs and ornaments. That he did not think solely in terms of concepts and issues, as the Florentines tended to do, is proved by the fact that these conflicting elements are not resolved in his art. (The facing page is blank.)

44. PRESENTATION OF THE HEAD OF HANNIBAL TO PRUSIAS. Pen. Louvre, fol. 41a. In this composition the interplay of space and actors is worked out in a similar way to that devised by Ghiberti for the *Isaac* scene of the East Doors of the Baptistery of San Giovanni in Florence. The young man who here appears accidentally to walk in on the scene establishes a continuity with the spectator of comparable intensity to that of Esau in Ghiberti's representation, who stands out in relief as he strides into the picture space. The decoration of the building includes references to antique sculpture both in the free-standing figures and in the representations of Roman emperors, probably derived from coins, in the roundels above. (The facing page is blank.)

45. STUDY OF A FLOWER. Watercolor. Louvre, fol. 56a. Clearly a study after nature, this blue-grey iris is unique in the drawing albums, as is its isolation against the white background of the vellum folio, indicating that it is not part of a pictorial composition. (The facing page is blank.)

46. GOLGOTHA. Pen and brush. Louvre, fol. 57a. In the drawings of Jacopo Bellini the widest evocations of pictorial space occur in representations of the Crucifixion. Such scenes as this one show a preference for organizing the setting on a panoramic scale incorporating both an extensive foreground view and a vista leading to the far horizon. Both these elements were first utilized by Masolino in the now ruined Crucifixion fresco in the church of San Clemente in Rome. (The facing page is blank.)

47. VESSEL. Silverpoint. Louvre, fol. 58a. This drawing recalls studies in the perspective representation of utilitarian objects made by Uccello. While Uccello appears to have viewed the object in isolation as an opportunity for elaborating the internal mechanism of the construction, Jacopo Bellini seems to have regarded the object more as an end in itself. Whatever construction lines he employed are no longer visible. (The facing page is blank.)

48. ARCHITECTURAL SCENE. Pen. Louvre, fol. 69b. The thematic content of this drawing is not clear. Its main subject would appear to be the architecture, which, in many respects, recalls Florentine example. Jacopo has arranged his figures into logically constituted groups set off by independent actors, all of whom are endowed with appropriate gestures and expressions. A smartly dressed strolling gentleman is seen from the back, while a lame man struggling to walk on crutches is observed with curiosity by a mother and child. Meanwhile a group of monks and a tax assessor engage in dignified conversation with a third man while a group of figures gathered round a table attend to business at the far right. A horse and rider, followed by a laborer who joylessly carries watering pails, lead the eye of the viewer to the left, where at the far side a footless cripple crouches painfully by a wall.

49. ARCHITECTURAL SCENE. Pen, two sheets superimposed. Louvre, fol. 70a. The subject of this drawing has not yet been firmly identified. In creating a situation where recumbent figures confront the spectator feet first as their bodies diminish into the middle ground, Jacopo Bellini shows that he was interested in studying the dramatic potential inherent in the use of perspective, a problem in which his son-in-law, Andrea Mantegna, became deeply interested.

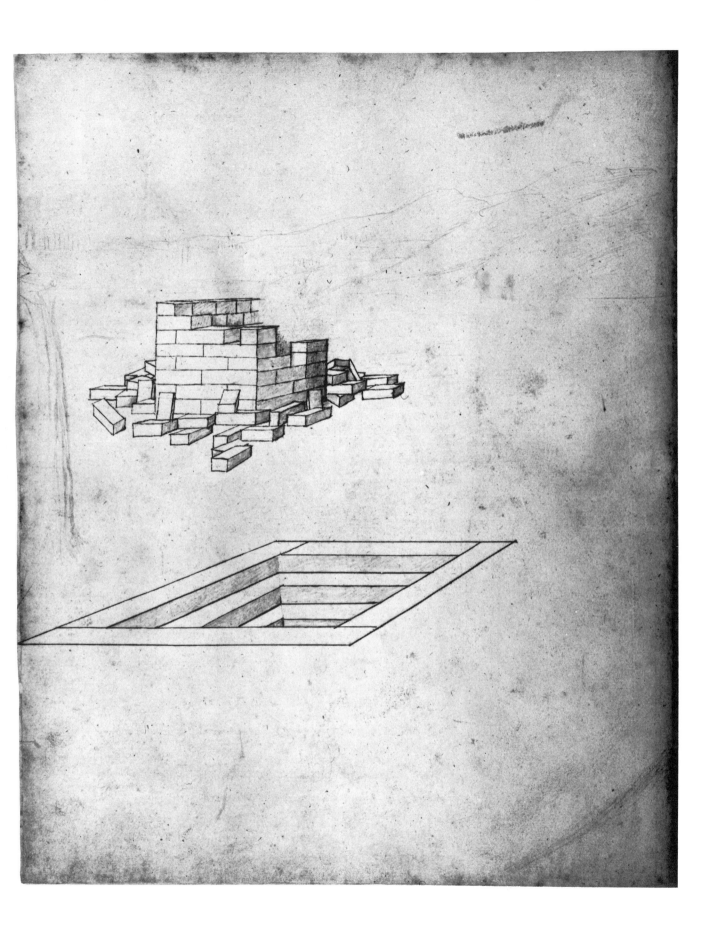

1. LANDSCAPE WITH WELL.

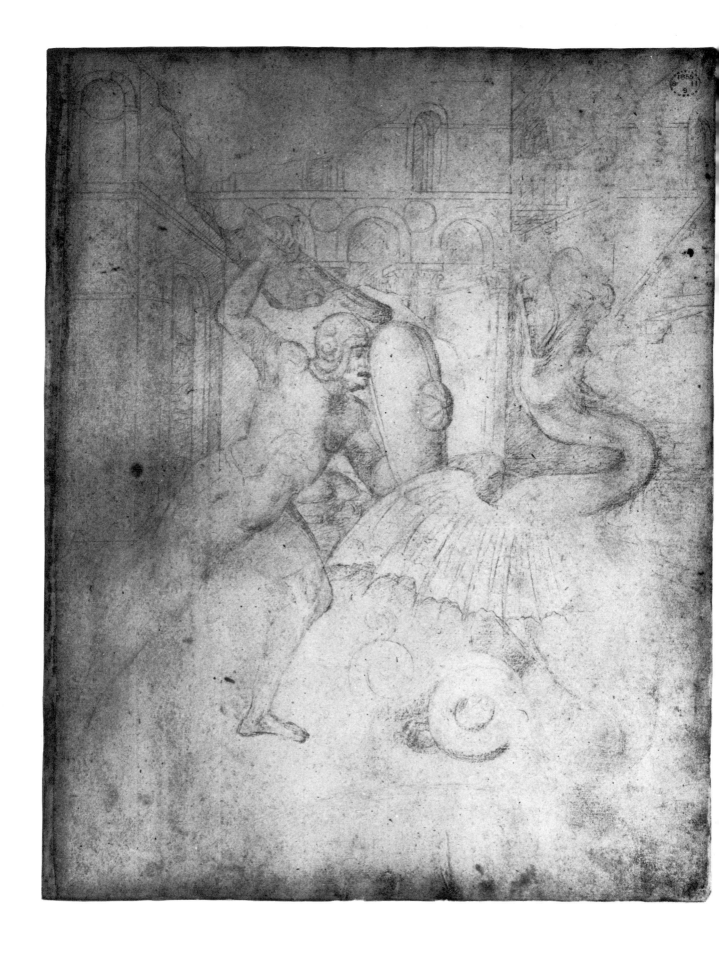

2. Soldier Battling a Dragon.

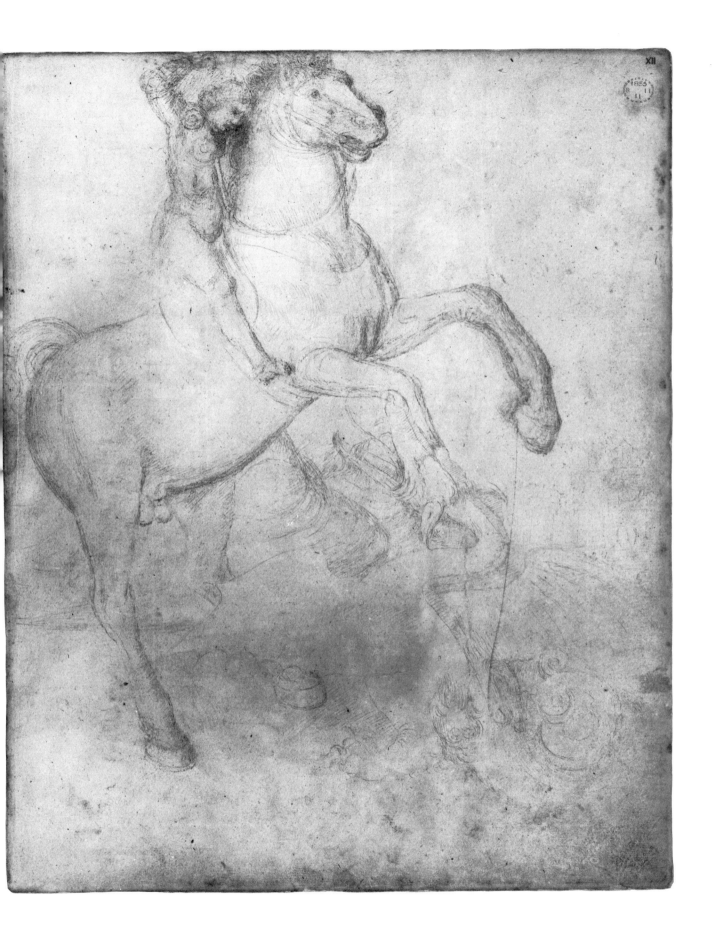

3. ST. GEORGE AND THE DRAGON.

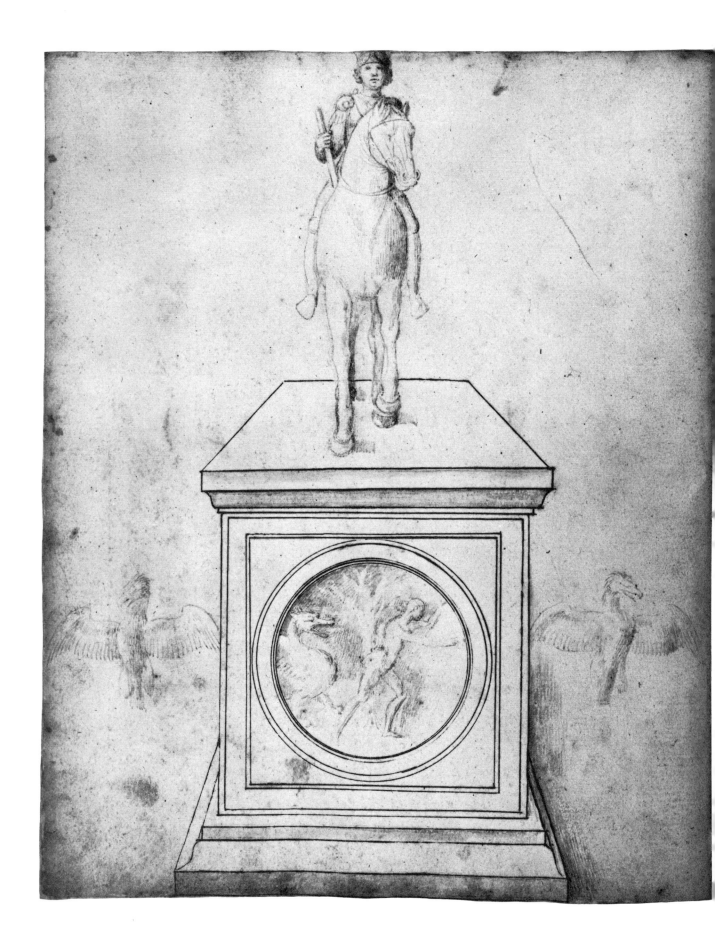

4. EQUESTRIAN MONUMENT.

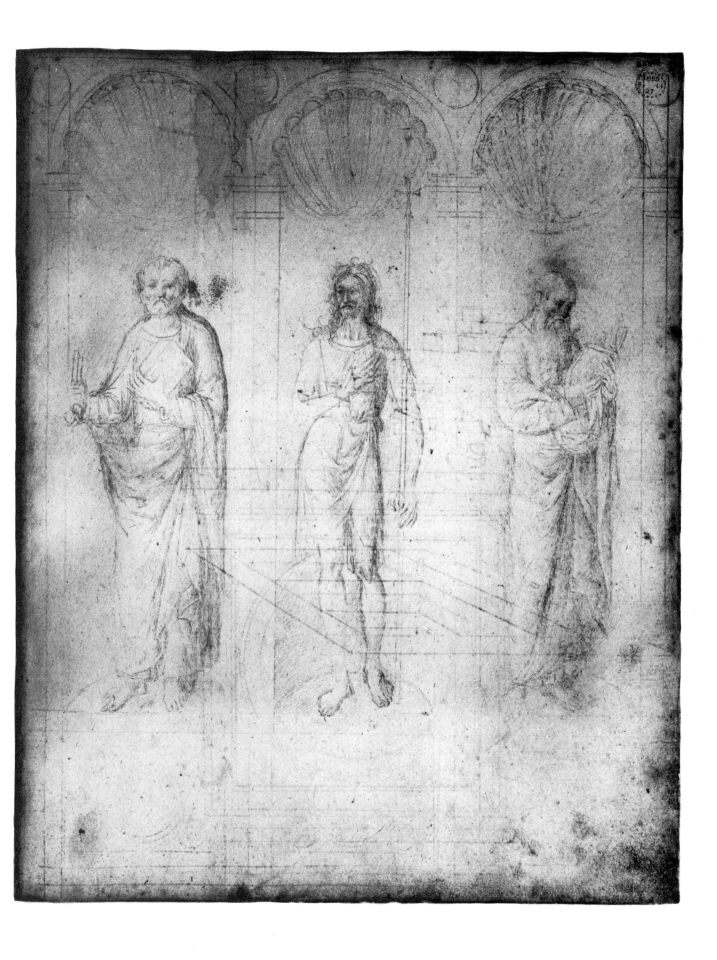

5. THREE SAINTS IN NICHES.

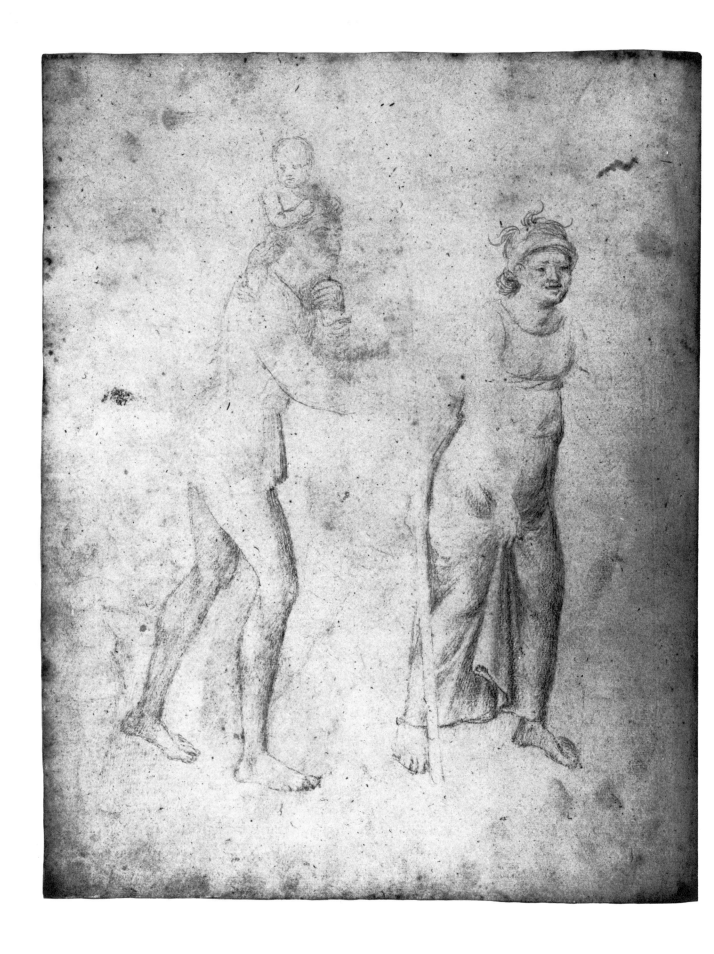

6. Bucolic Figures.

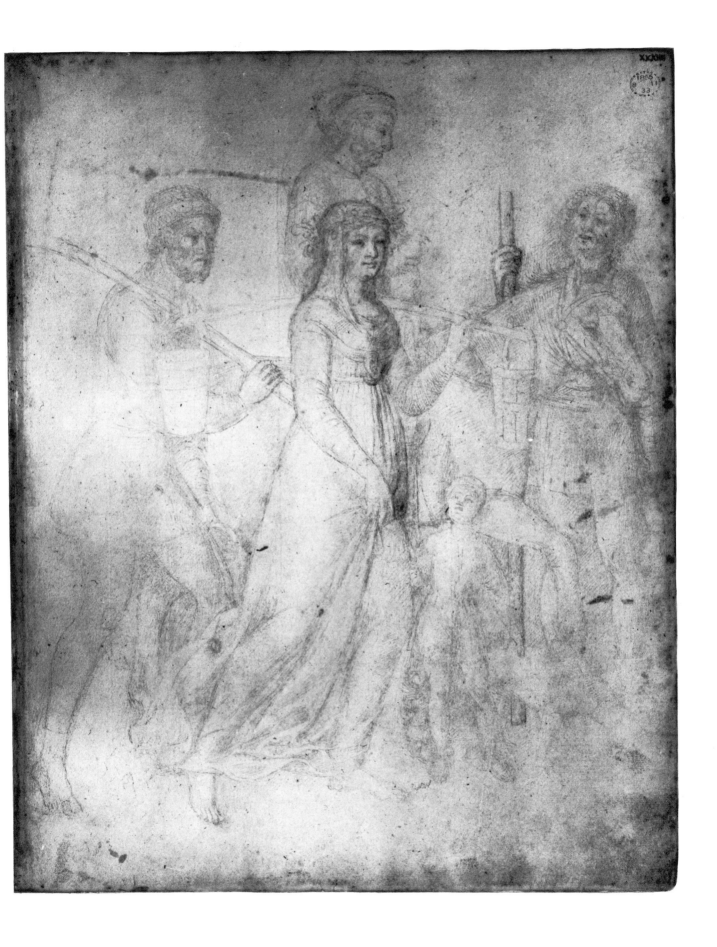

7. BUCOLIC FIGURES.

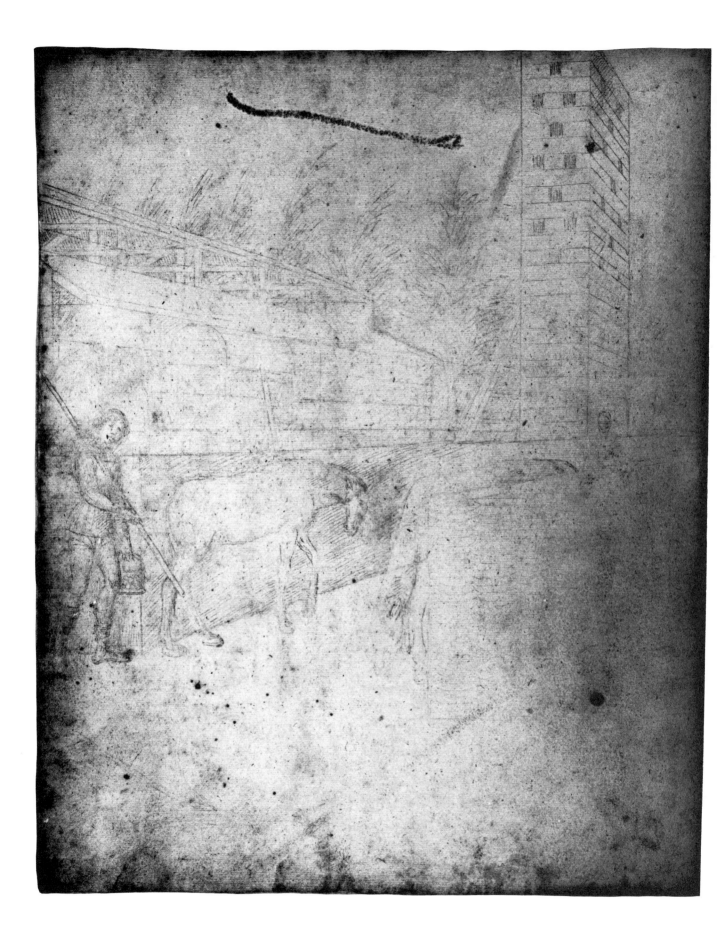

8. RUSTIC SCENE.

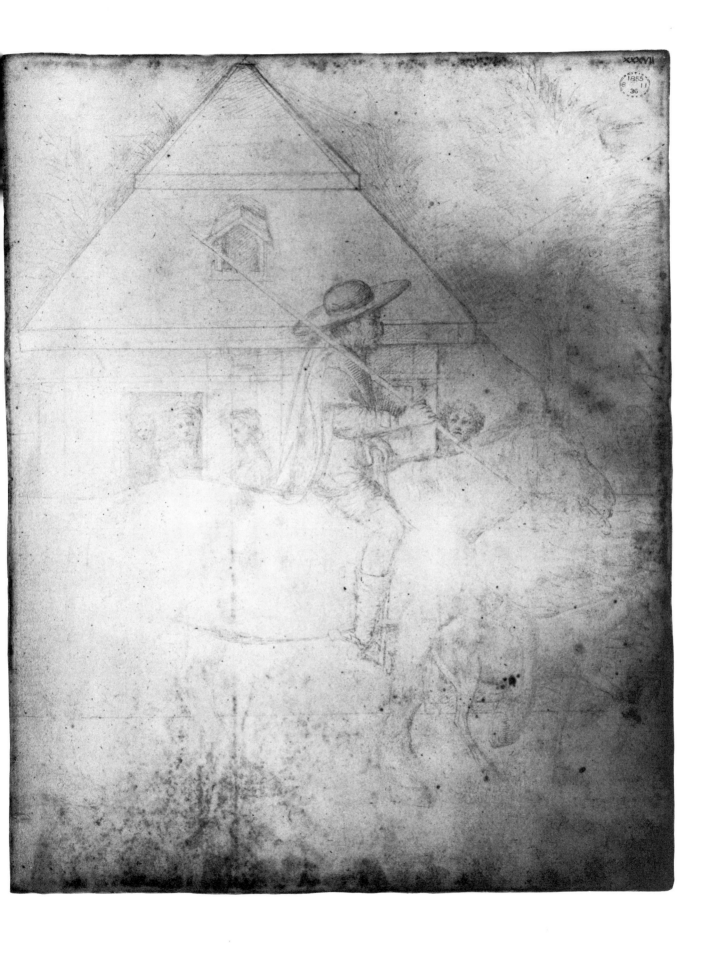

9. RUSTIC SCENE.

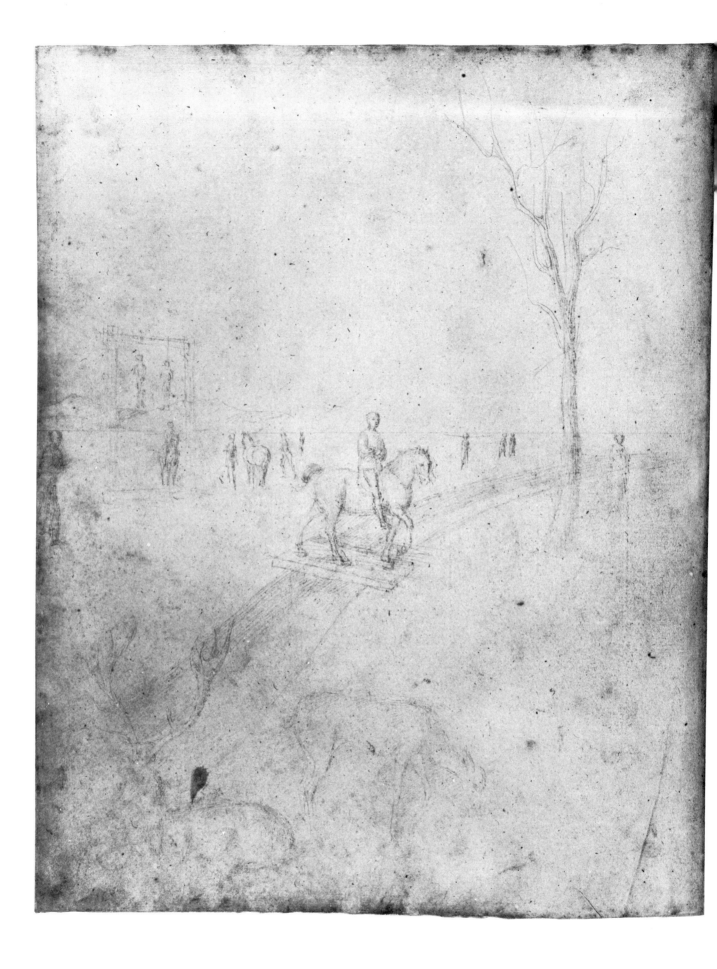

10. LANDSCAPE.

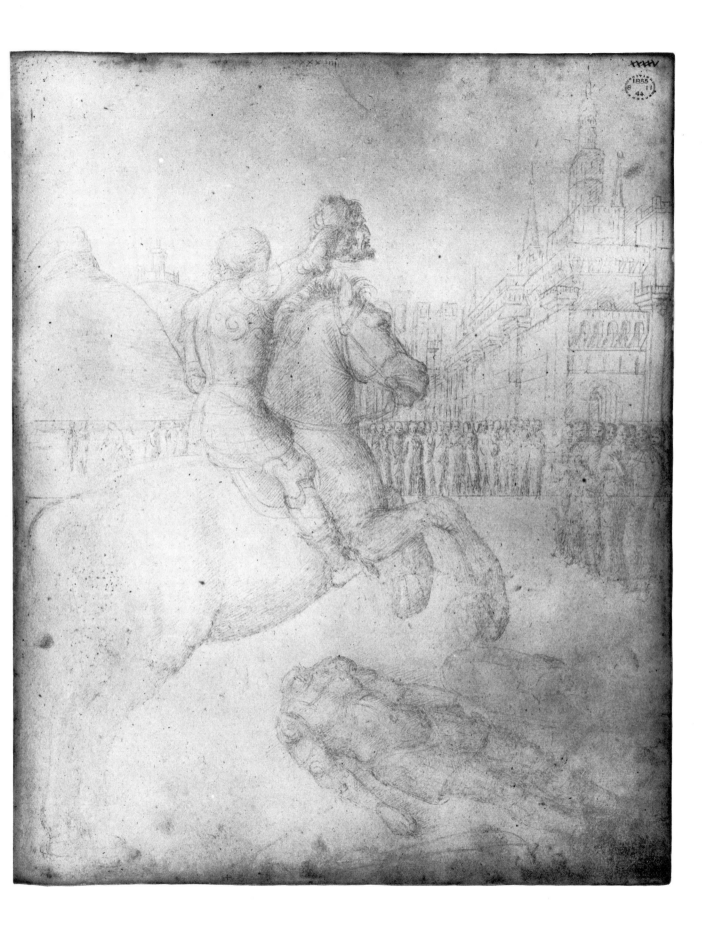

11.　DAVID WITH THE HEAD OF GOLIATH.

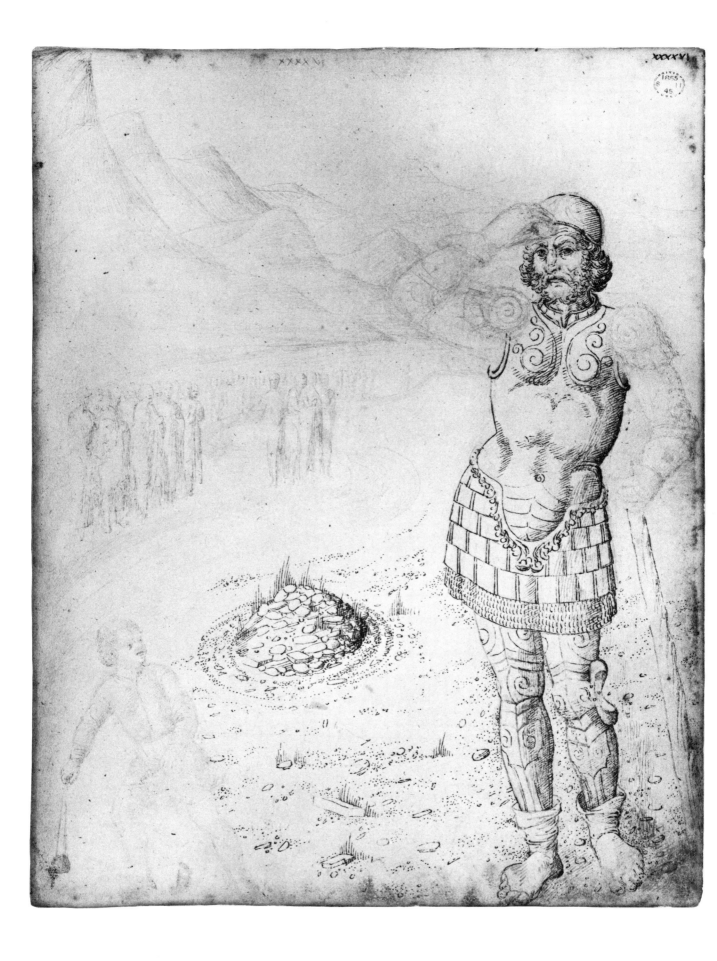

12. DAVID AND GOLIATH.

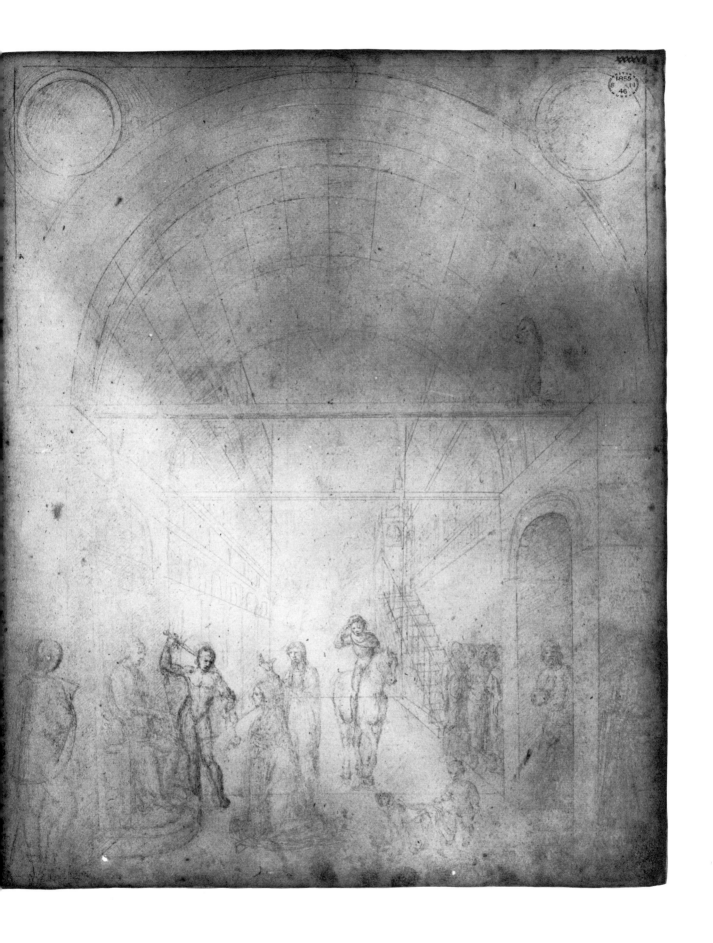

13. JUDGMENT OF SOLOMON.

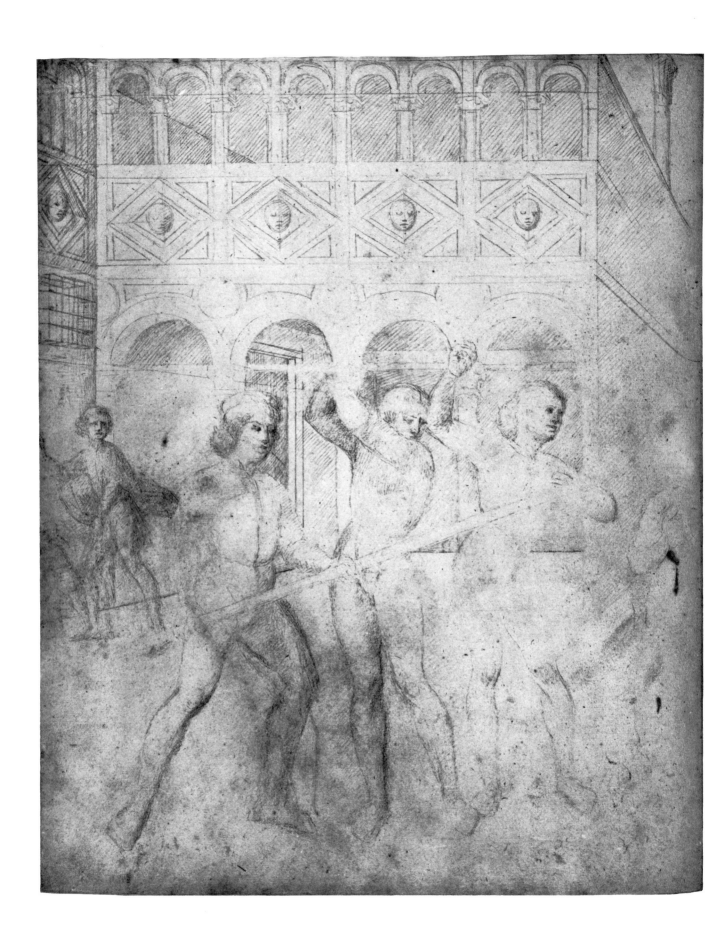

14. Figures in a Courtyard.

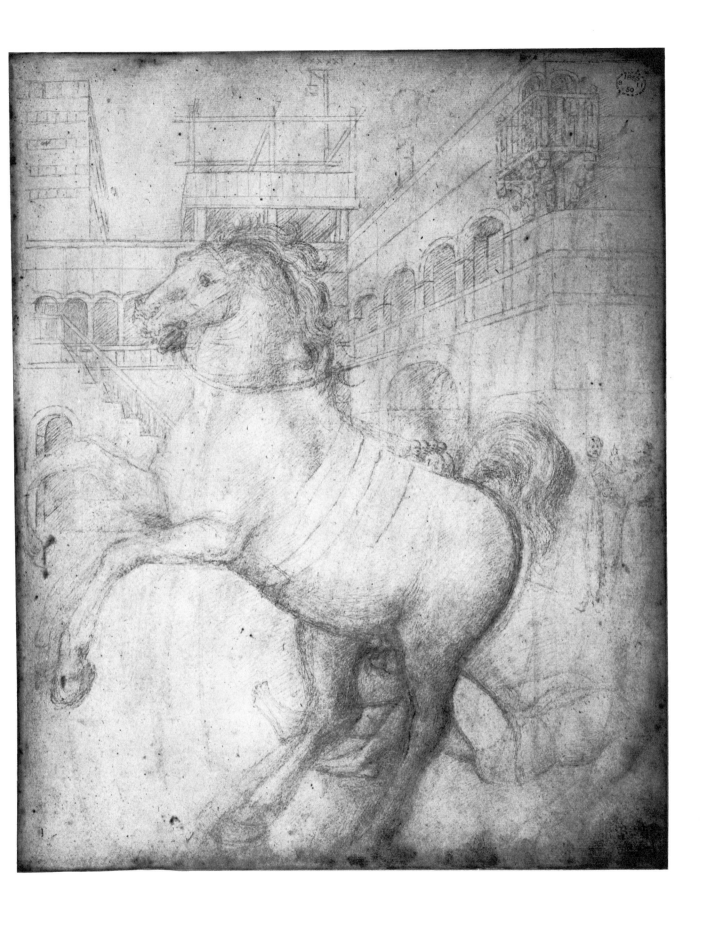

15. Punishment of a Criminal.

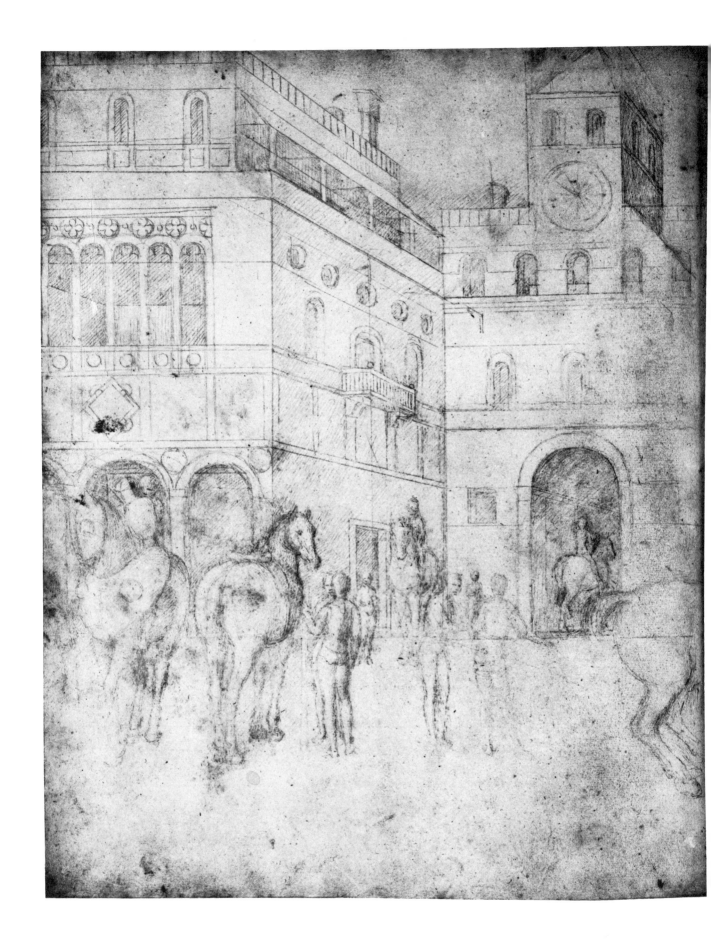

16. TOURNAMENT SCENE.

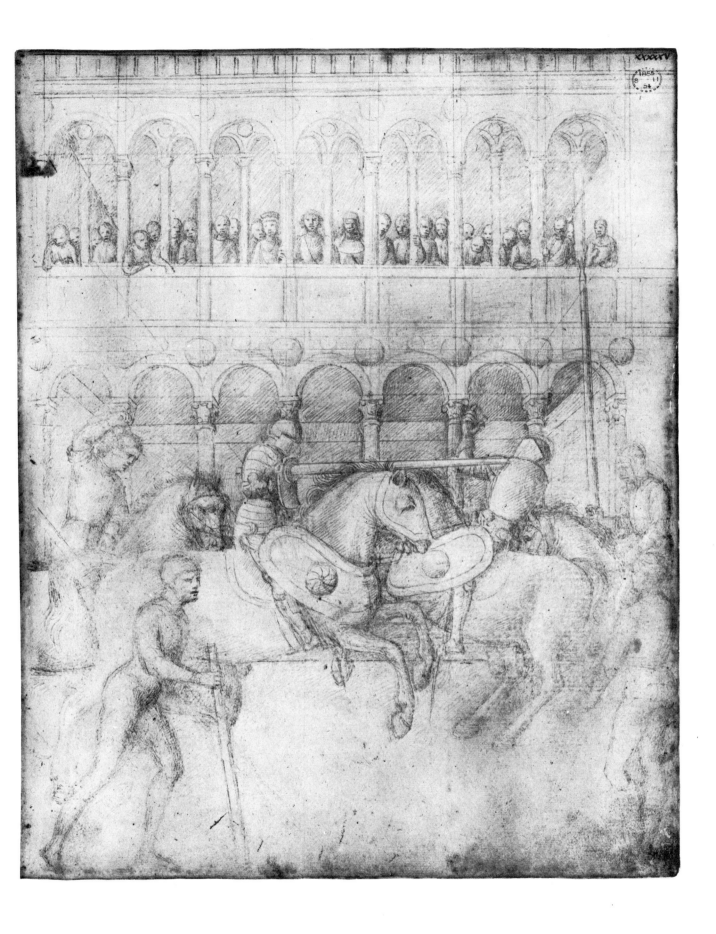

17. TOURNAMENT SCENE.

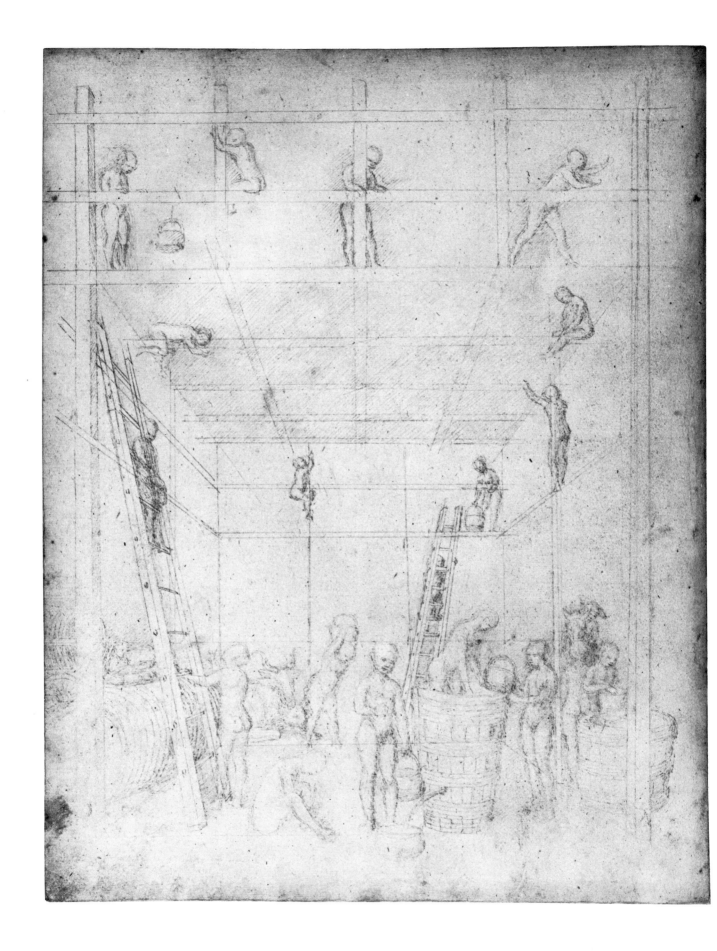

18. HARVEST SCENE.

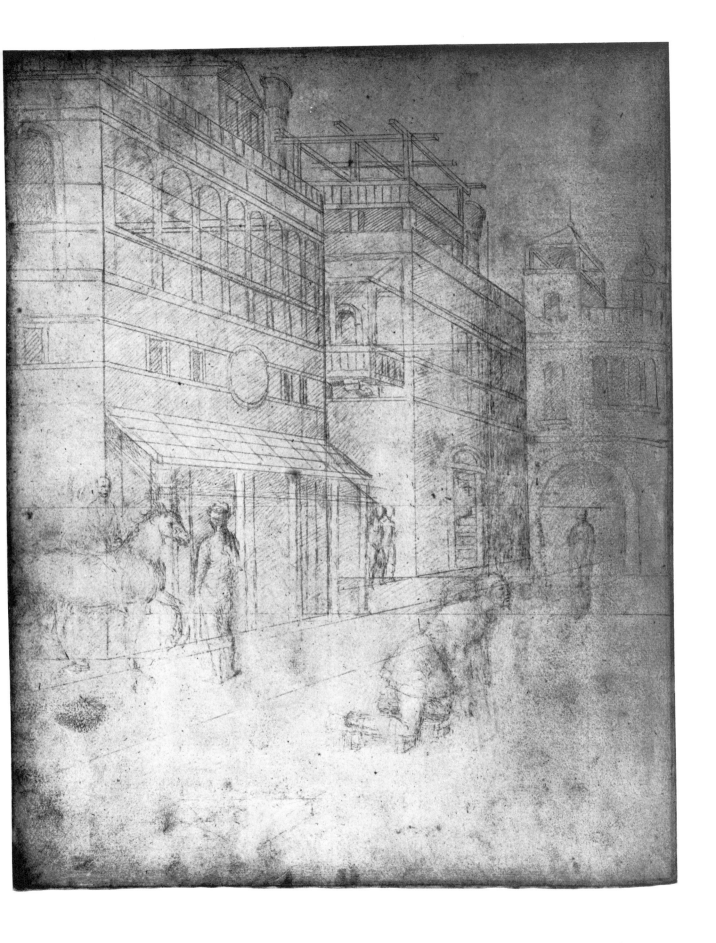

19. STREET SCENE.

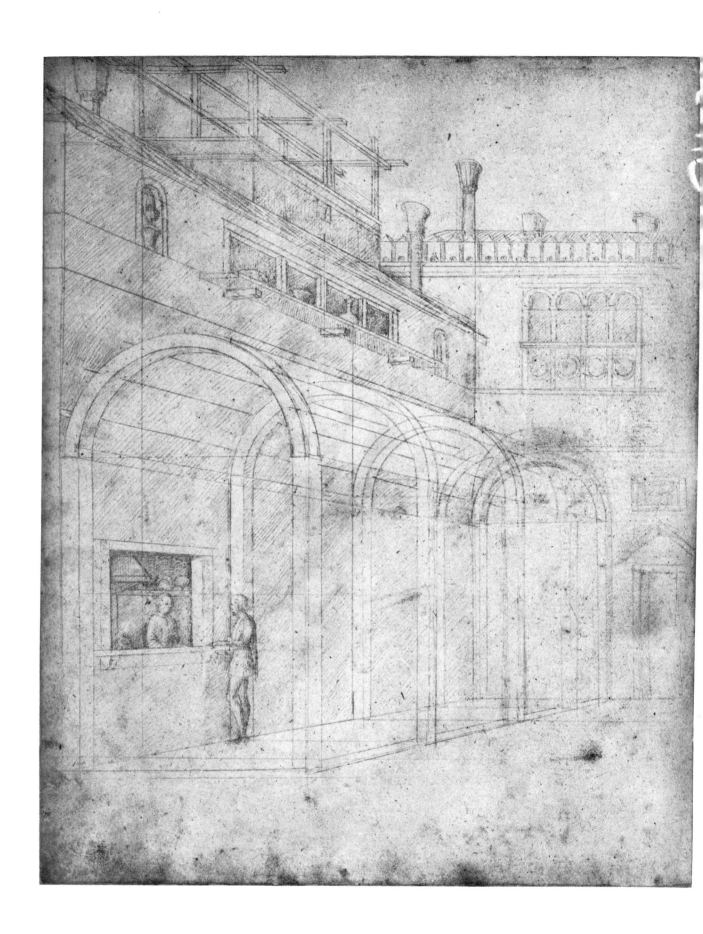

20. ARCHITECTURAL SCENE.

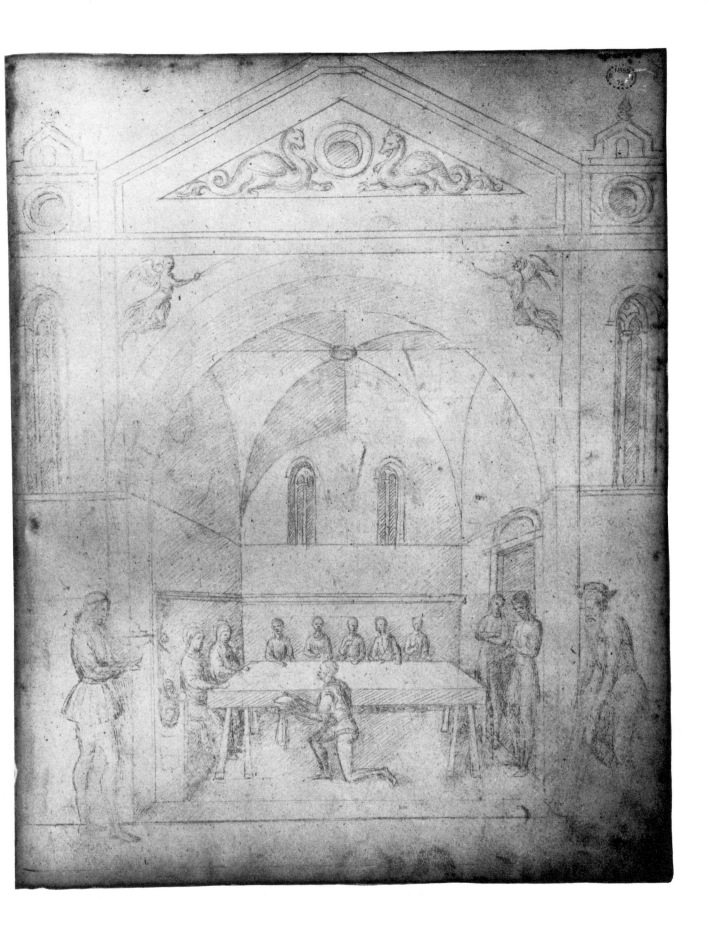

21. Marriage at Cana.

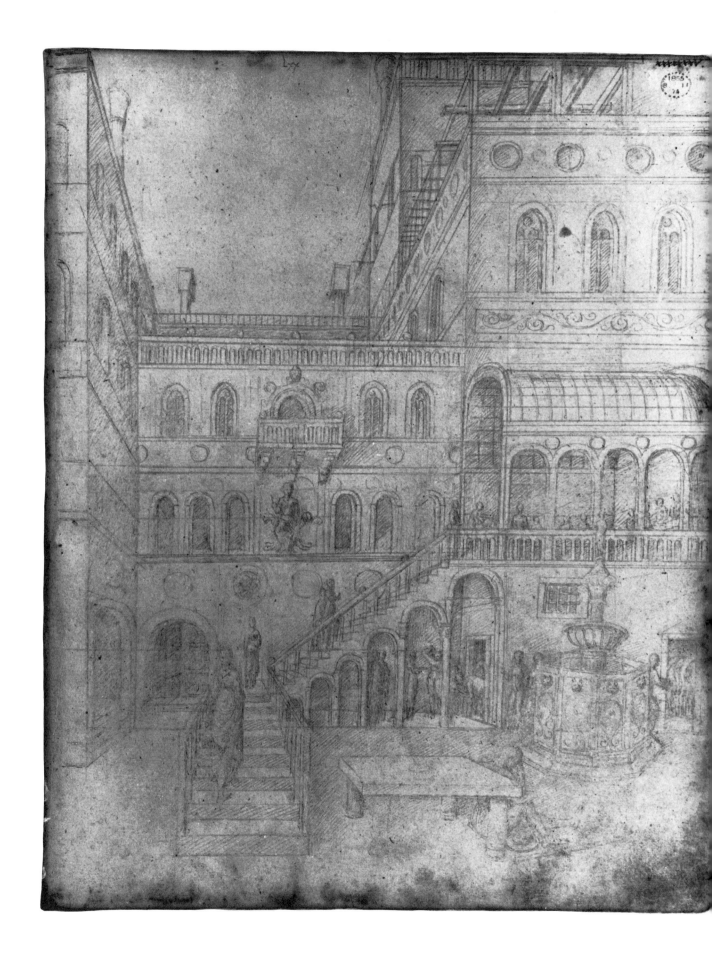

22. PALACE OF HEROD.

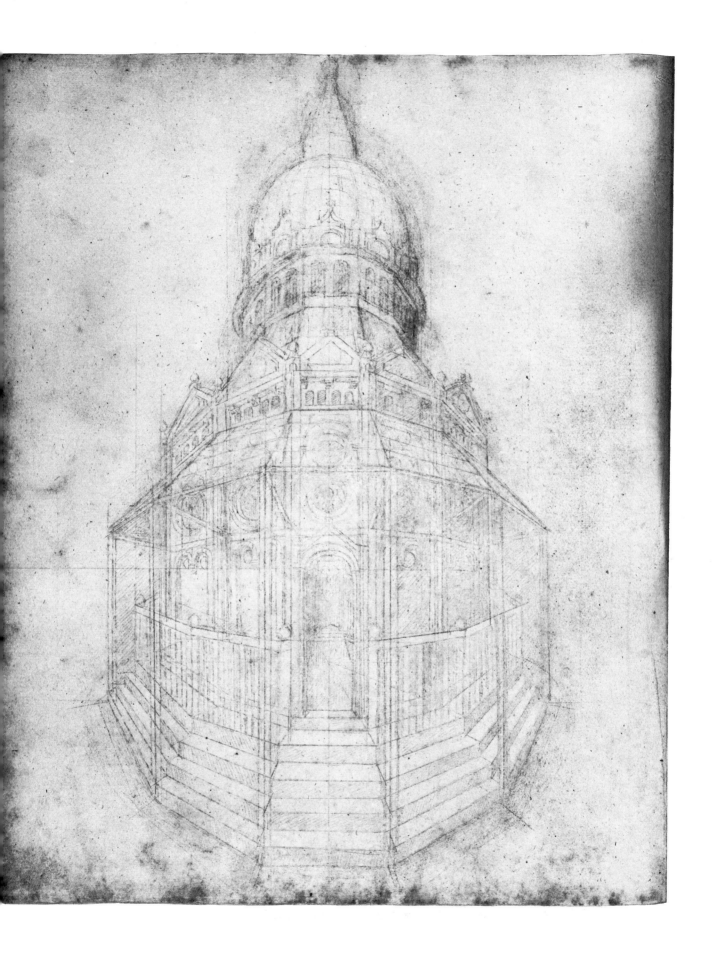

23.　Architecture.

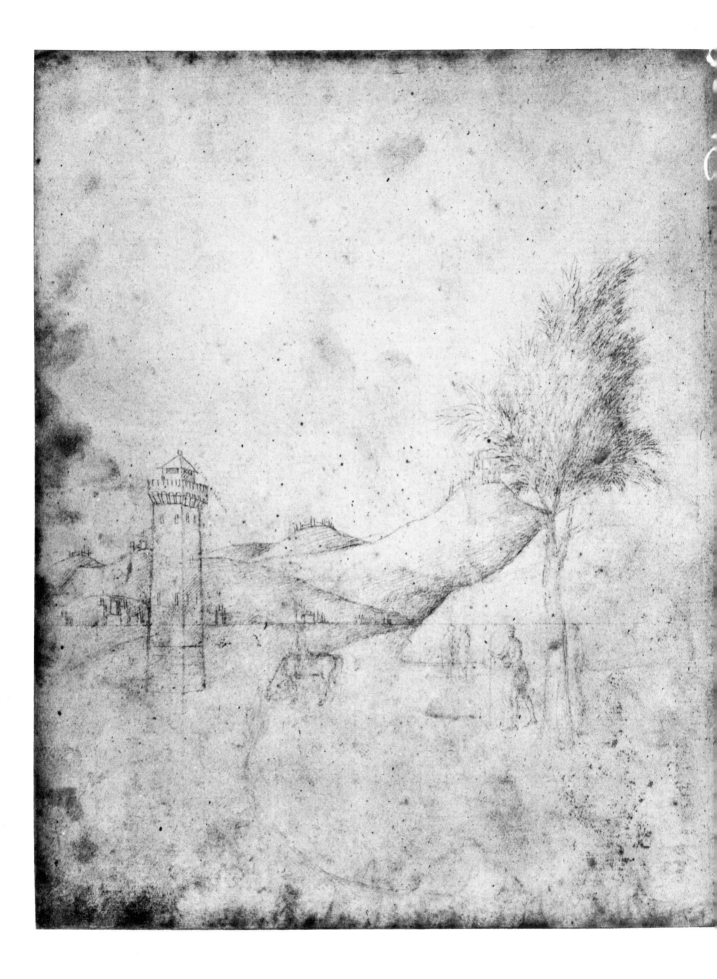

24. LANDSCAPE.

25. CHRIST NAILED TO THE CROSS.

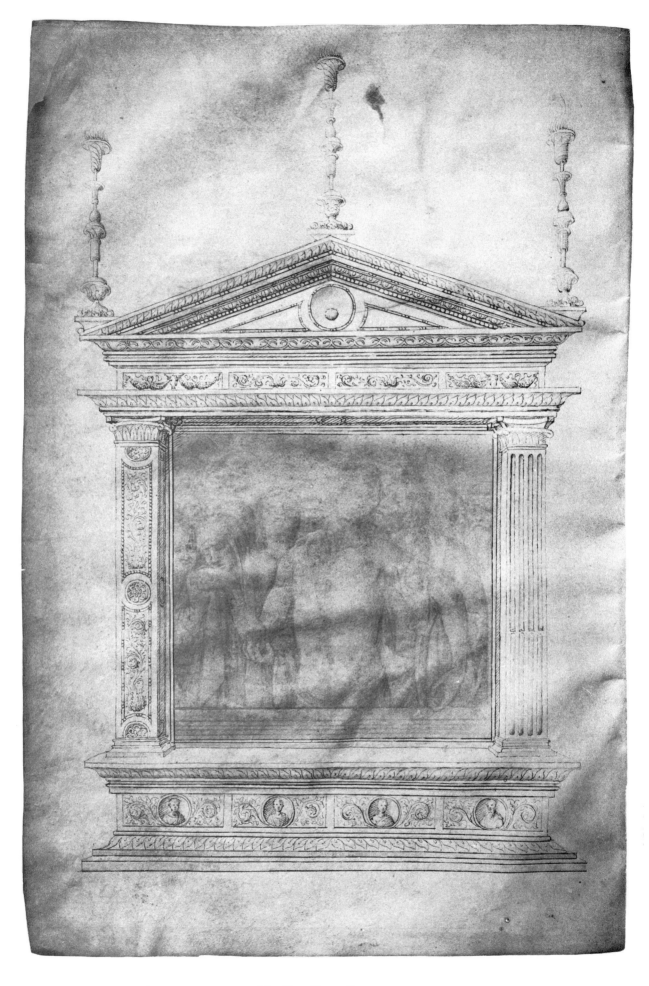

26. THE DEAD CHRIST.

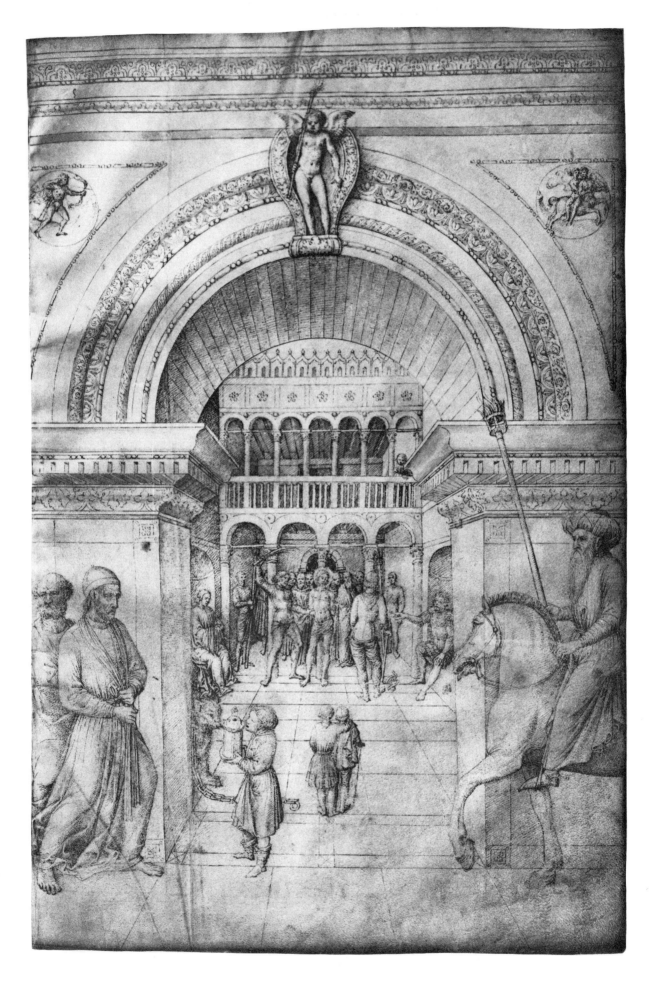

27. FLAGELLATION.

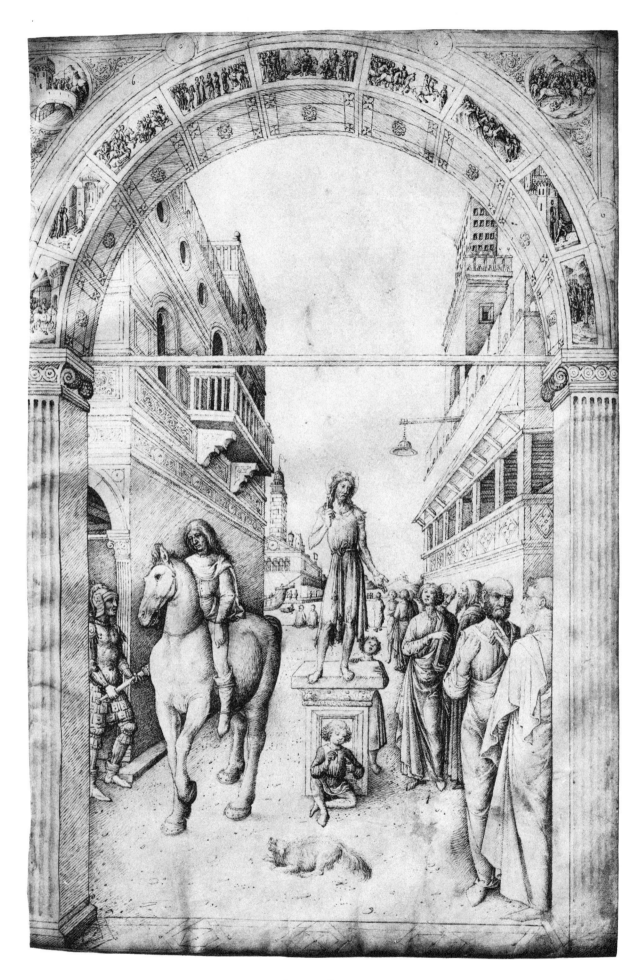

28. ASCETIC PREACHING.

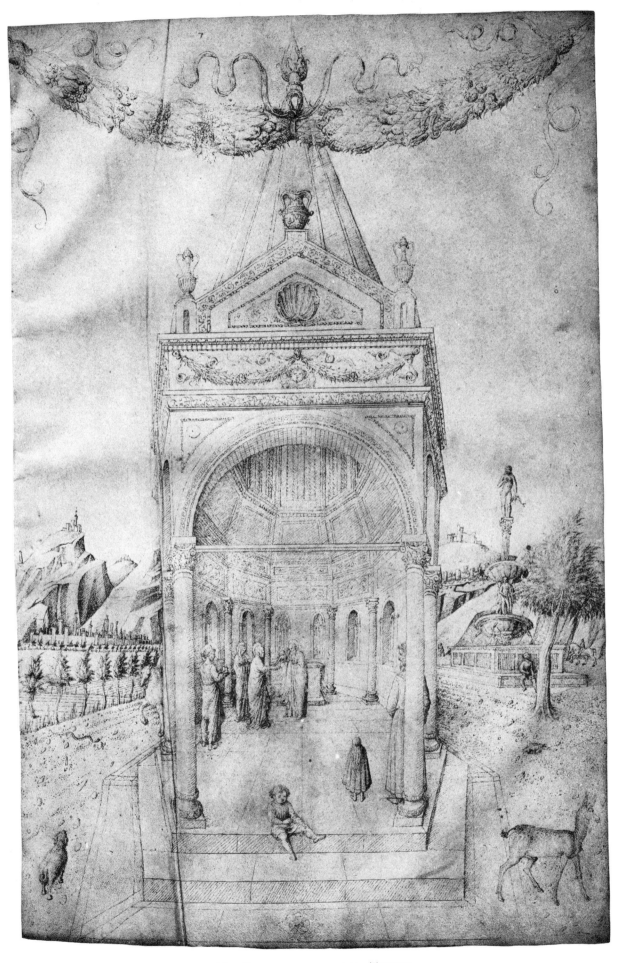

29. PRESENTATION IN THE TEMPLE.

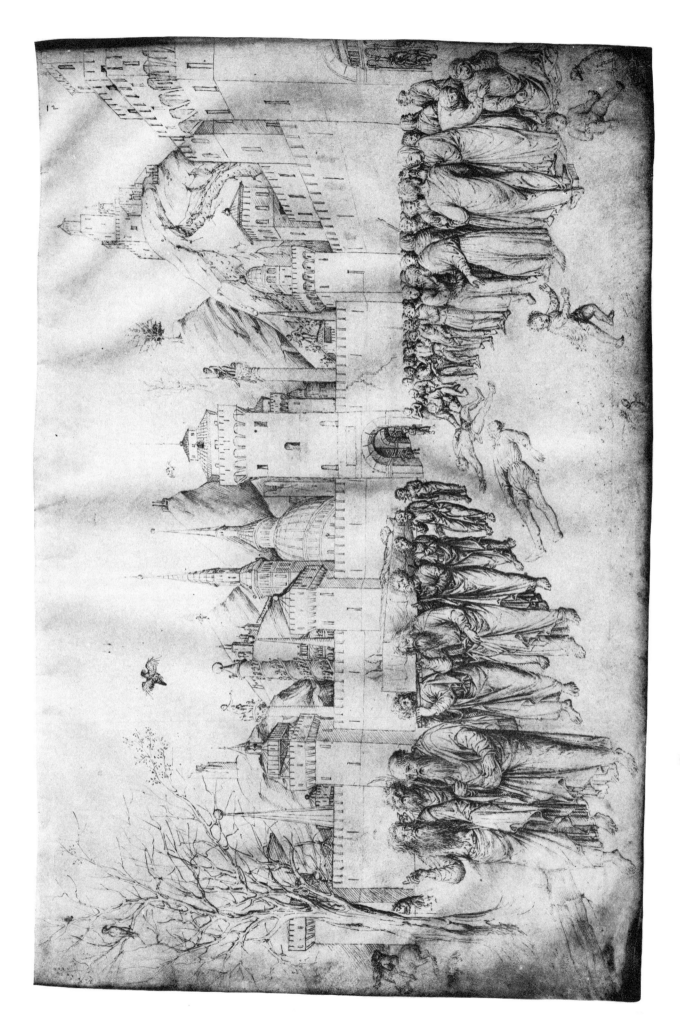

30. FUNERAL OF THE VIRGIN.

31. MEMENTO MORI.

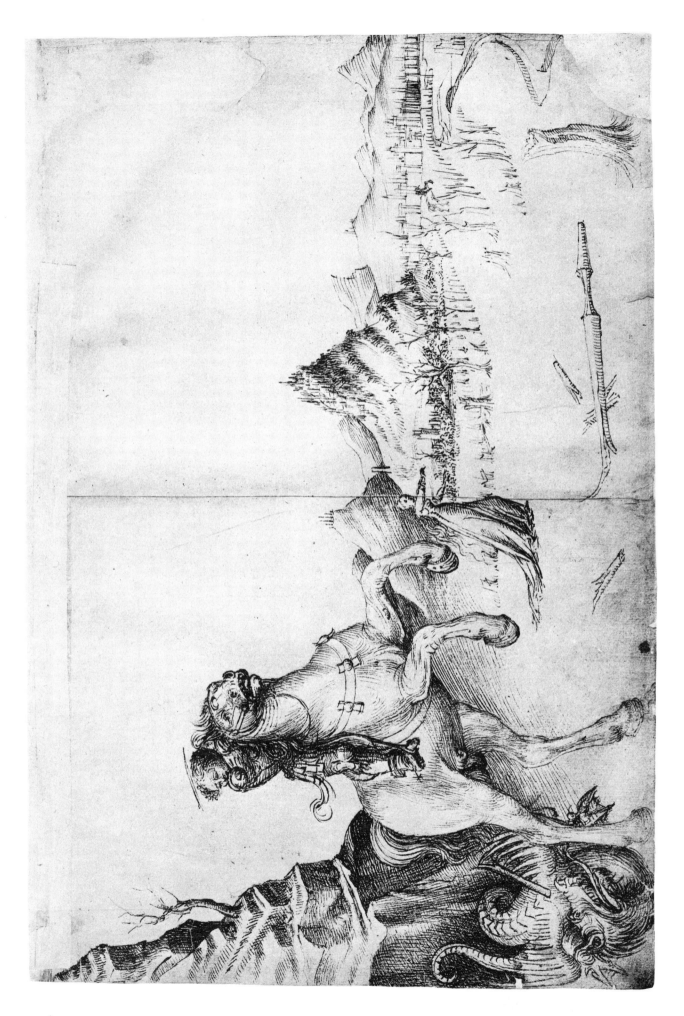

32. ST. GEORGE AND THE DRAGON

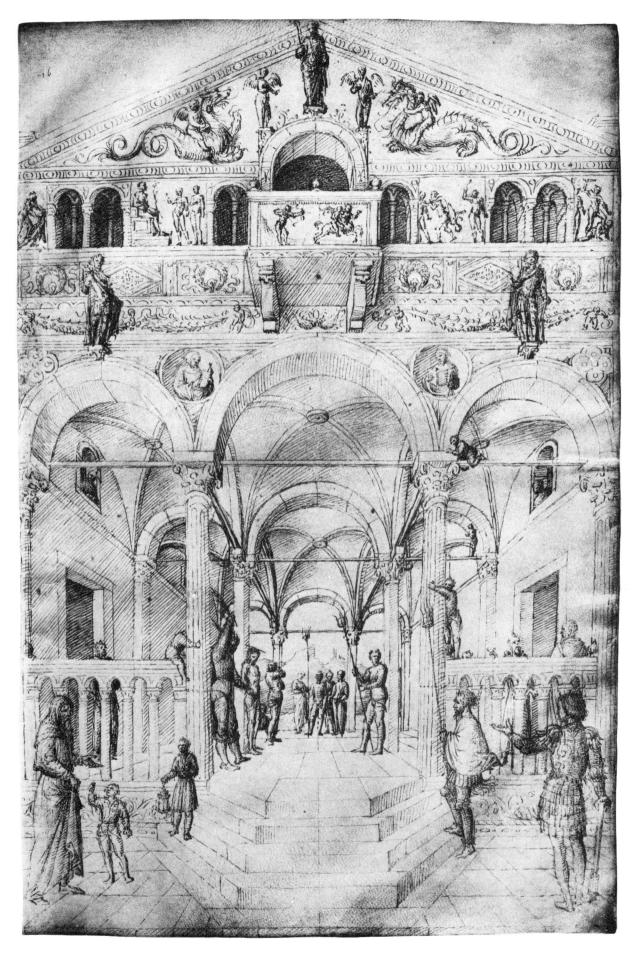

33. FLAGELLATION.

34. FEAST OF HEROD.

35. Feast of Herod.

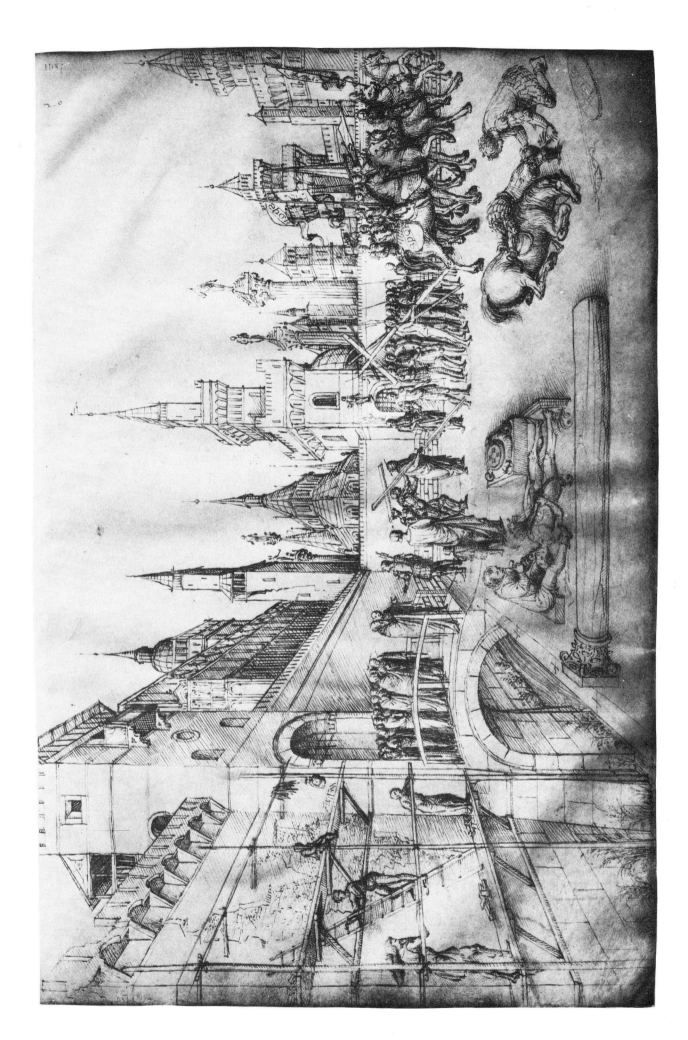

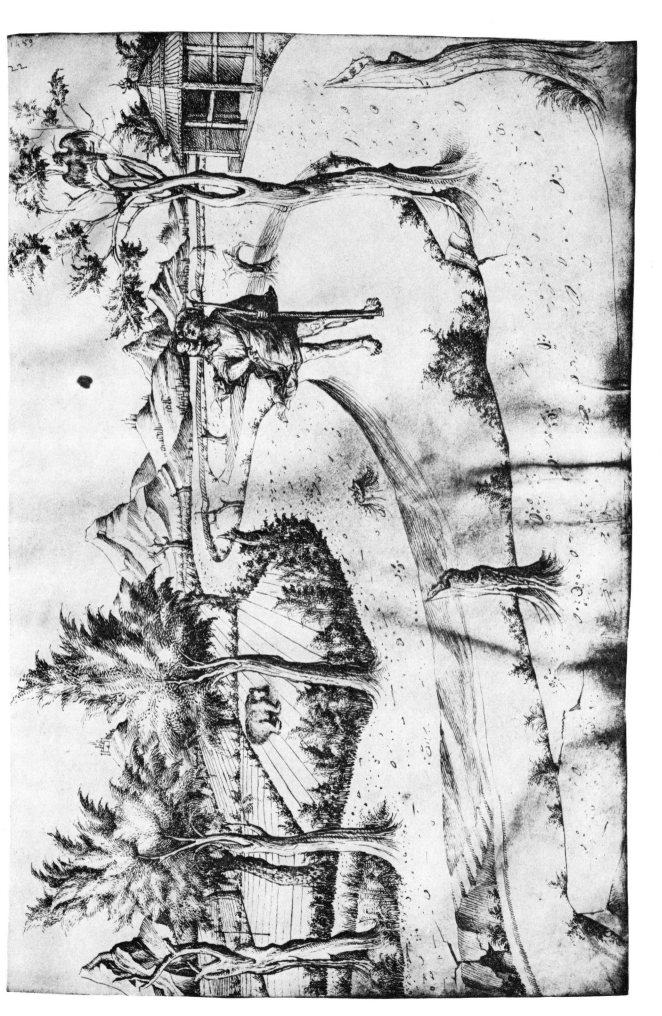

37. St. Christopher.

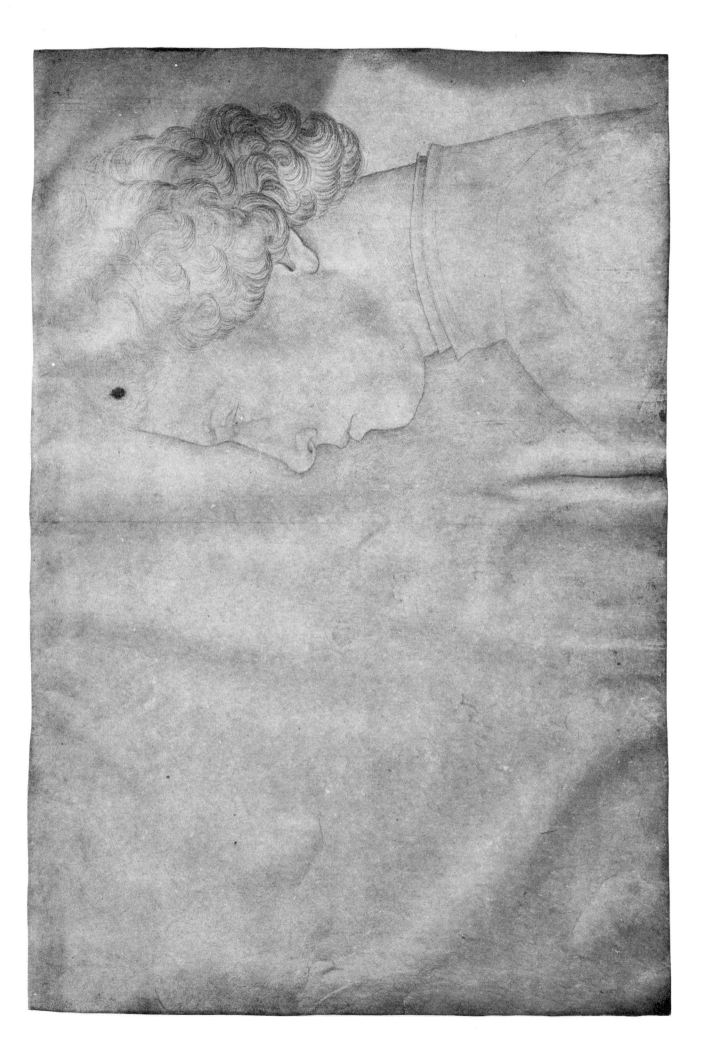

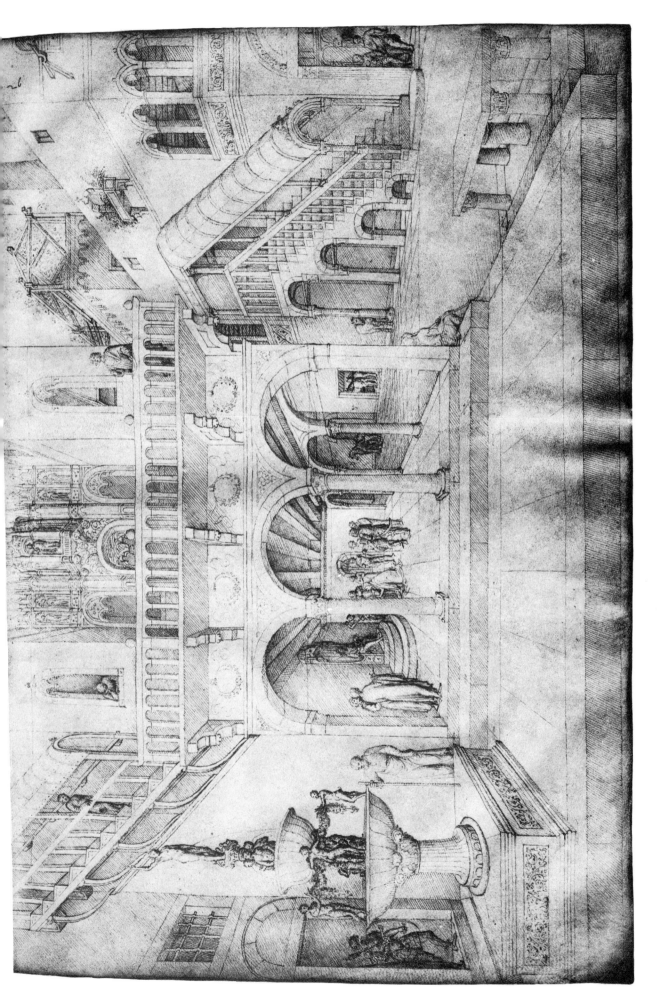

39. JUDGMENT OF SOLOMON.

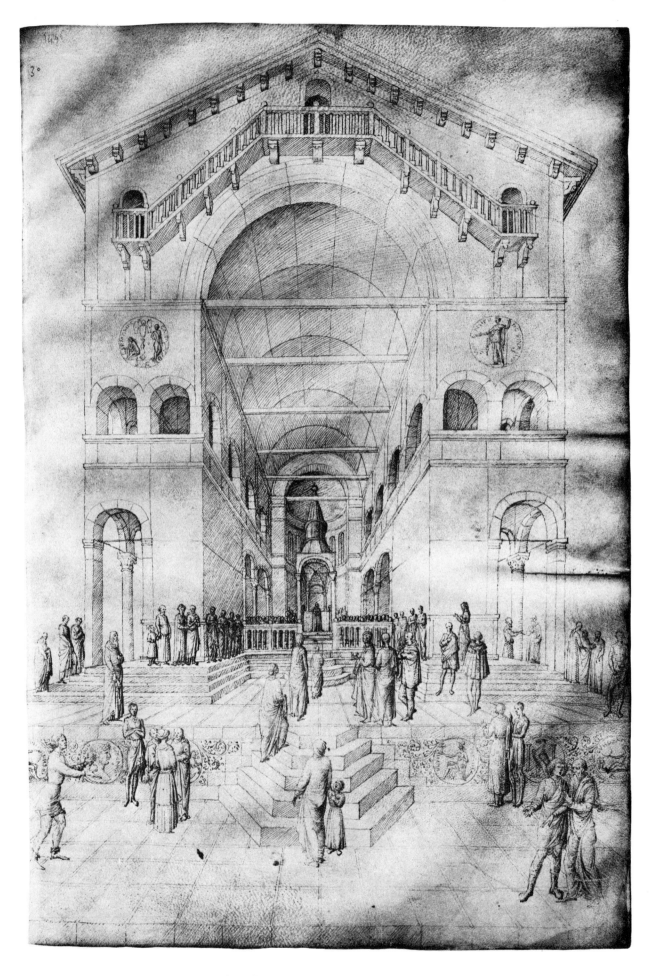

40. PRESENTATION IN THE TEMPLE.

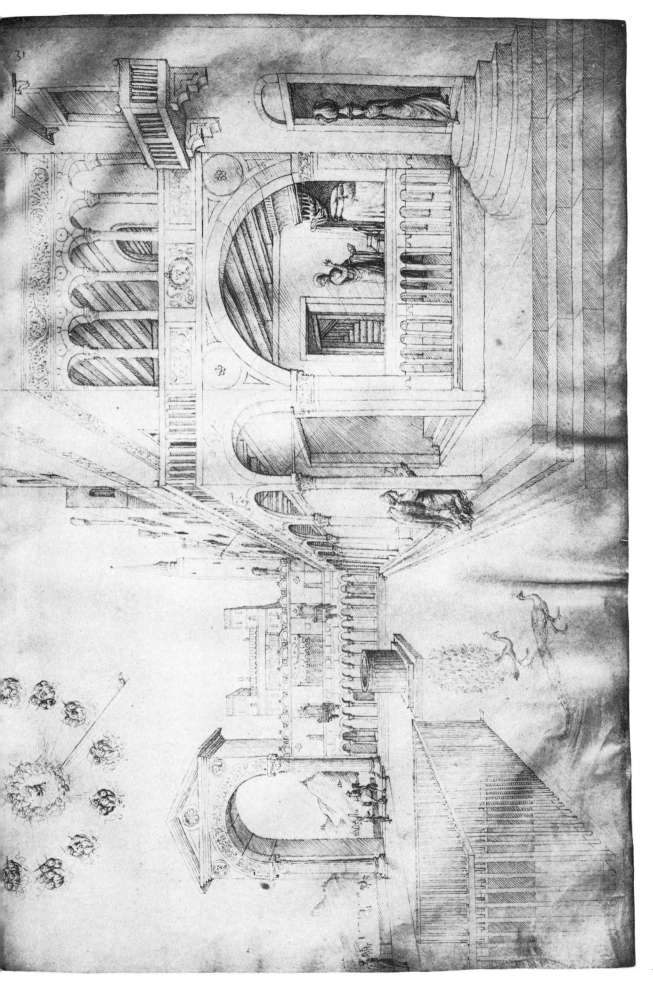

41. ANNUNCIATION.

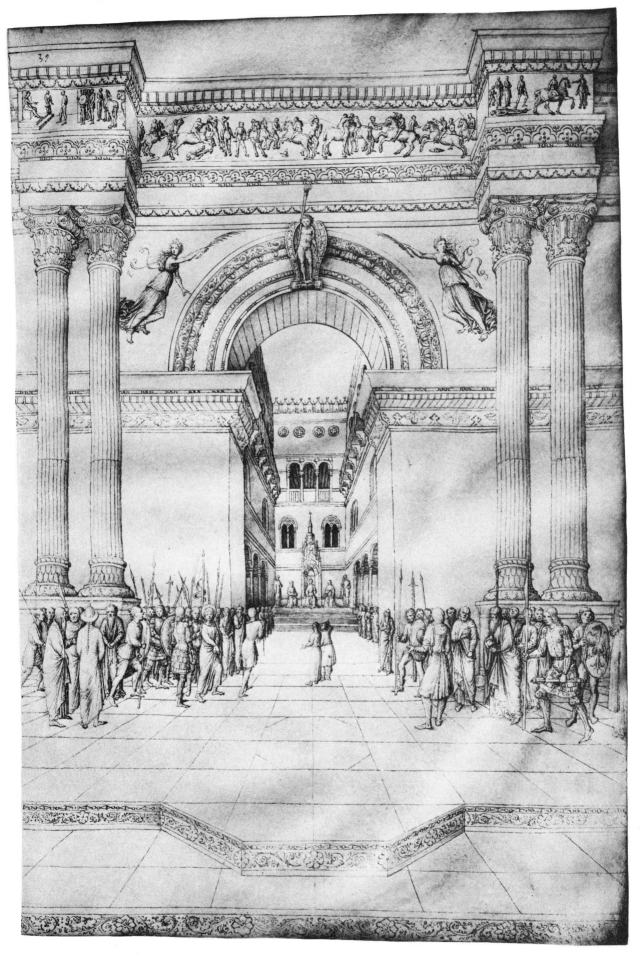

43. CHRIST BEFORE PILATE.

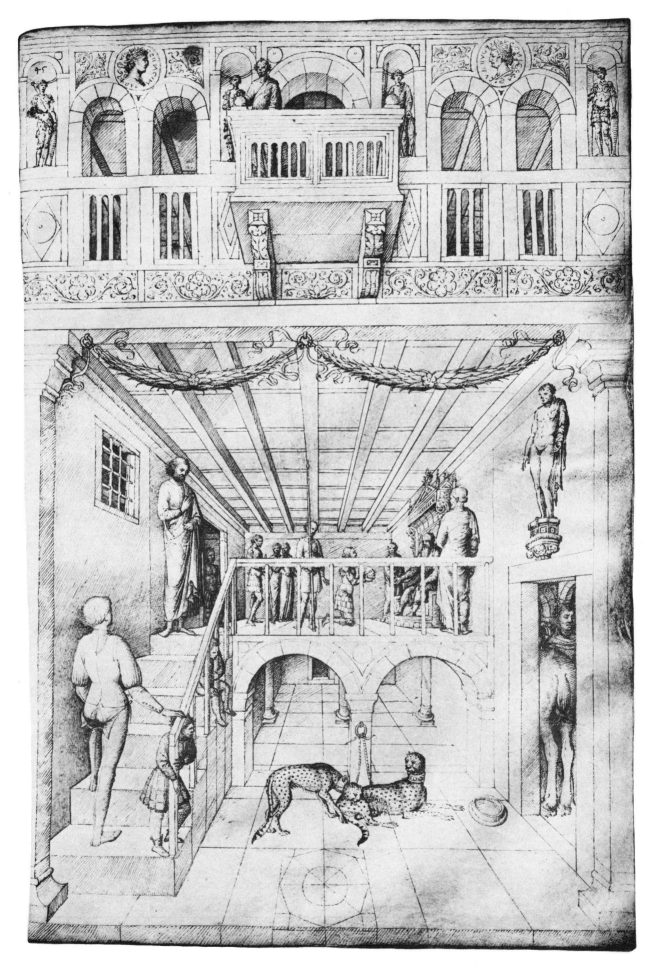

44. PRESENTATION OF THE HEAD OF HANNIBAL TO PRUSIAS.

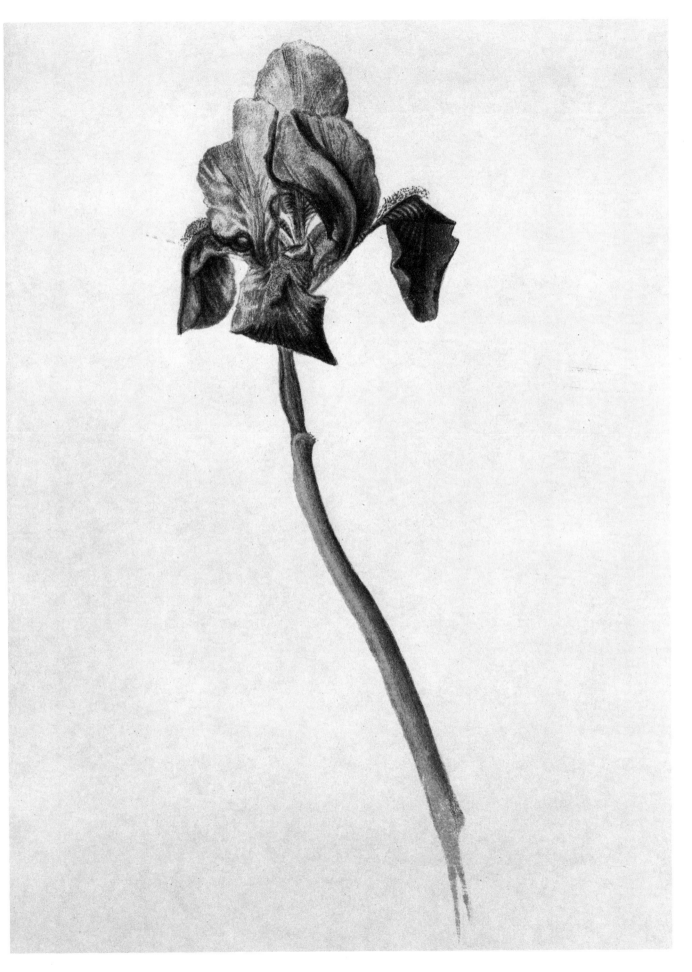

45. STUDY OF A FLOWER.

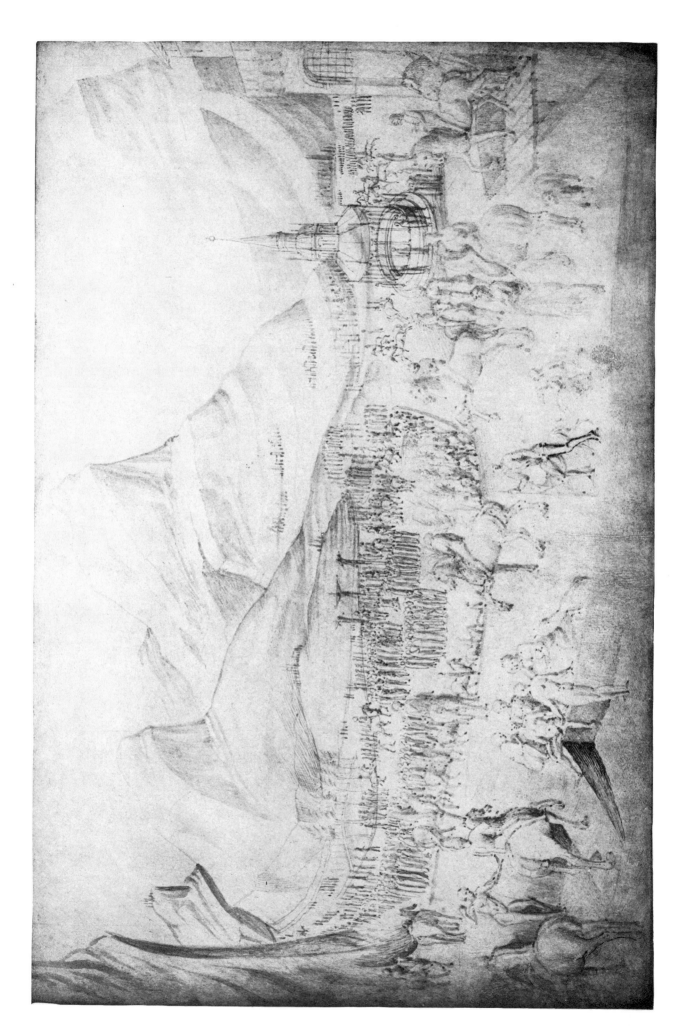

46. GOLGOTHA.

47. VESSEL.

64

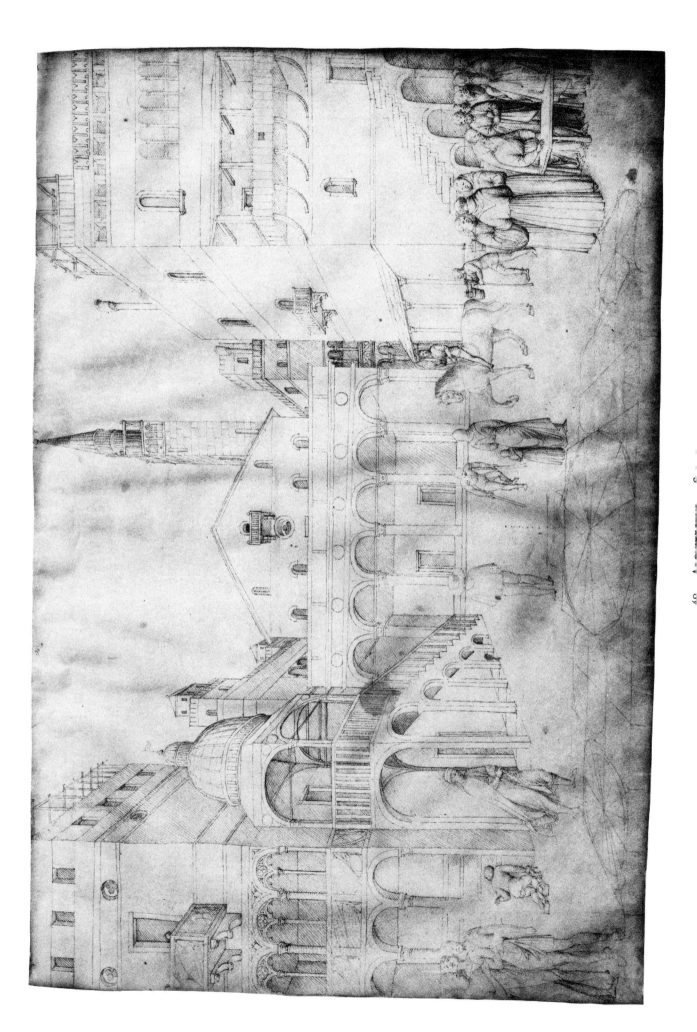

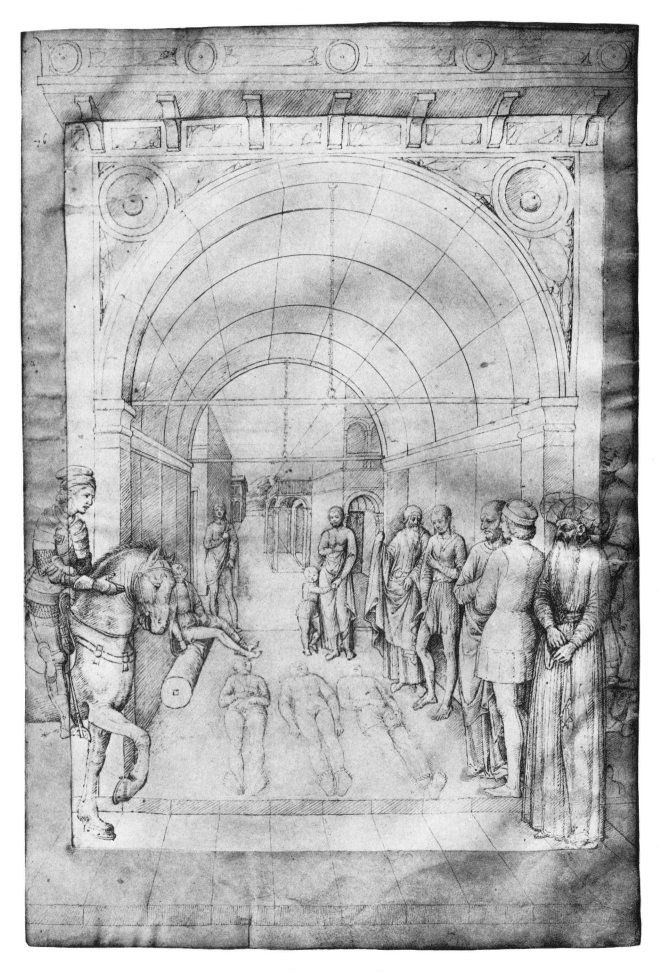

49. ARCHITECTURAL SCENE.